SOUTHAMPTON

ROBERT COOK

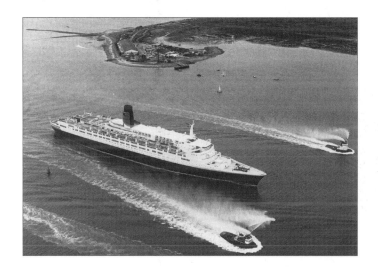

The History Press

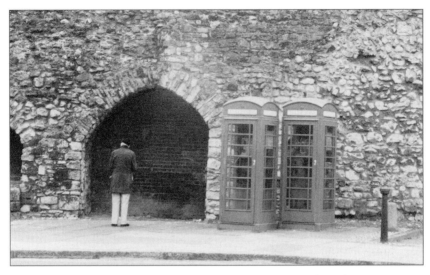

A man fumbles with his loose change outside the red telephone boxes next to a preserved section of the medieval town wall in 1993. (R. Cook)

First published in 1996
This edition first published in 2009

The History Press
The Mill, Brimscombe Port
Stroud, Gloucestershire, GL5 2QG
www.thehistorypress.co.uk

British Library Cataloguing in Publication Data.
A catalogue record for this book is available from the British Library.

ISBN 978 0 7524 5112 1

Typesetting and origination by The History Press
Printed in Great Britain

CONTENTS

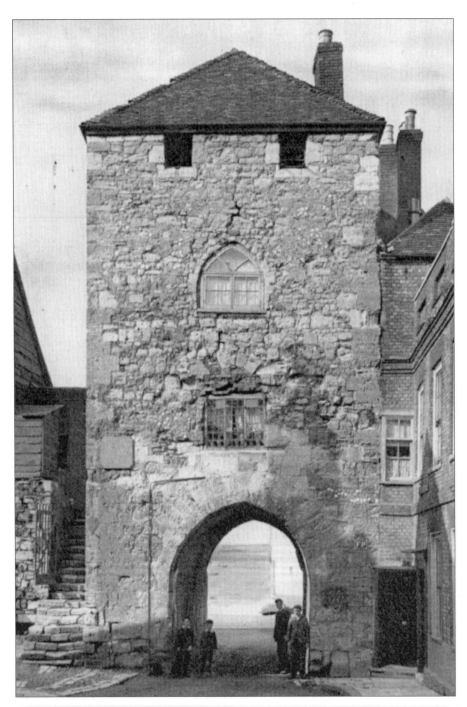

West Gate, 1904. West Gate leads to West Quay, the main medieval dock from which Henry V sailed to Agincourt in 1415 and the Pilgrim Fathers to America in 1620. The tiled roof was removed in 1935. An adjoining seventeenth-century warehouse served as a fish market and clothing merchants, being restored as a Tudor merchant hall in 1975.

INTRODUCTION

Nowadays a glittering city, Southampton was a county borough until 1964. The next step in its evolution is under way as it moves toward a unitary authority in 1997 and the loss of fifteen county councillors' voices in local government. The size of the local government authority will triple, but there will still only be forty-five City Councillors managing affairs. The aim is greater efficiency in all local government services. But as history teaches the open-minded, perfection always eludes us. The Romans had their own efficiency targets and brutal ways of achieving them. Like other empires since, their leaders grew complacent and self-indulgent – and disappeared. Only death is a certainty. The Romans from Caesar to Claudius (54 BC–AD 43), valued the Southampton region, creating a settlement at Bitterne and a road east to Chichester. Travel routes from the south coast to the Seine were of paramount importance.

Commercial settlements were often linked to existing royal and eccelsiastical centres whose names often included 'wic' (from the Latin *vicus*). Hamwih, the precursor of modern Southampton, lay where the rivers Test and Itchen met, near a royal vill called Hampton. Excavation has revealed a settlement occupying around 50 acres which was first established around AD 20 and reveals European influence through its artefacts. Trade with Italian merchant cities reinforced Southampton's importance during the sixteenth century. Among other things, the merchants came for Cotswold wool. But difficulties on the overland trade routes east and rivalry on the Cape route forced the Italian city states' decline. The last of the Venetian argosies bound for Southampton was wrecked off the Needles in 1587.

But new honours awaited Hamwich. The Danish conqueror Canute was proclaimed king here in 1017. The town found importance following the Norman invasion, keeping the invaders in touch with home. Bubonic plague was a less welcome visitor than the Normans in the mid-fourteenth century. Carried by infected rats in grain ships and transmitted by flea bites, plague was known as the 'beggar's disease' because it mostly affected the poor – and most people were poor. Plague killed one quarter of the English population. Farming practices changed thereafter, with more pastureland and less arable because fewer labourers were available to work the land. Also towns were growing. New religious practices following Henry VIII's Reformation encouraged new ways of working. Industry and capitalism were just around the corner and the port of Southampton would enjoy new prosperity. On the down side, this led to overcrowding. Slums grew apace, along with health and social problems. Policing was difficult. But there were some fresher quarters and by 1750 the town came to prominence as a spa and residential resort. This encouraged the beginnings of a service industry. In the fifty years before 1801 the population doubled to nearly eight thousand.

Being such a key port, with proximity to three good rivers, shipbuilding prospered from the days of wooden ships. Builders at Bucklers Hard made great warships in the class of HMS *Victory*, from around three hundred oak trees apiece. The nineteenth-century railway revolution stimulated further dock improvements including White Star's Ocean Dock for a new wave of giant liners, the most notable being the *Titanic*.

For a long time the minority with money have made all the key decisions behind the scenes. The last Earl of Southampton was one of King Charles I's wealthiest and most loyal supporters and paid for it by losing 10 per cent of his estates. Laying low during Cromwell's Republic, he rose again during the Restoration. His Bloomsbury estates carried the town's name to London. They were among the first properly planned and most fashionable areas. Southampton (later Bloomsbury) Square offered fine views looking north toward the great mansion of Southampton (now Bedford) House. The estate passed via his daughter Rachel to his son-in-law, a member of Lord Russell's family, upon his demise.

The power of the mighty few continues because crucial decisions cannot be made by those without money. Once upon a time those who did not like the established order of things could do as the Pilgrim Fathers had done when they left Southampton in 1620 for the New World. But except for outer space there are no new worlds left and people must find ways of living together in the global village, of which Southampton is but an enclave. Wars have dashed many men off to fight for freedom. During the Second World War the front line came to town. Wing Commander Hodsoll's report, as Inspector of Air Raid Precautions, was very critical of local government leadership, probably because he resented them being in control of Air Raid Precautions. He criticized the chief constable for going sick after the second night of bombing even though the poor fellow had been badly hurt in a motor accident during the air raid.

But we all have our pet hates. I have some sympathy with poet T.S. Eliot who passed through Southampton a number of times on his way to the Ocean Terminal and his native USA. In 1945 he said that industrialization had created an apathetic population ripe only for despotism. But I have had my idealistic moments, such as when I visited Southampton's Gaumont seeking inspiration from watching a re-run of the anti-war musical 'Hair' in 1974. I am wiser now. The economic and social systems have moved on. I don't know how much they are responsible for the alienation and hopelessness of so many, or the greed of others. These systems have certainly contributed to some of the images in this collection, some of which are almost contemporary. This is deliberate, because I see no point in viewing the past without thinking of the present and future.

SECTION ONE

WITHIN THESE WALLS

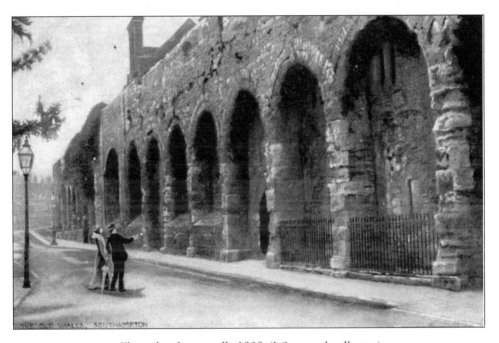

The medieval town walls, 1908. (J. Ounsworth collection)

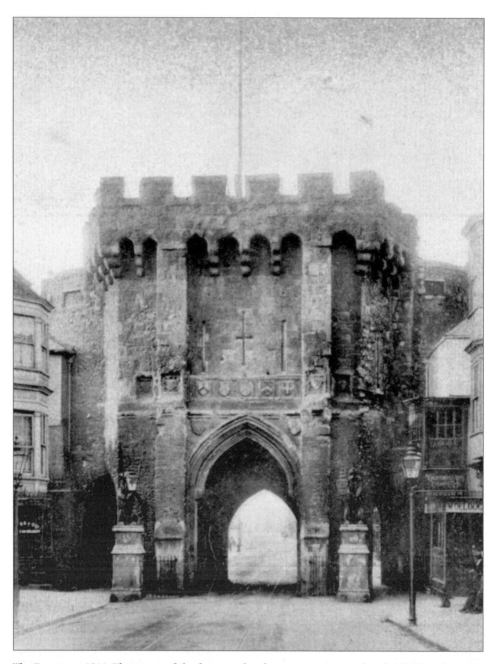

The Bargate, *c.* 1911. This is one of the finest medieval town gates, restored in the 1860s and given a fifteenth-century façade. It has served as a Guildhall, courthouse, woolhouse and maritime museum. When it was fitted out as a Second World War air raid shelter, people joked whether such an old structure could survive against Hitler's bombs. Ironically, it was one of the few central buildings that did. Fortunately, so did the famous sixteenth-century Tudor House which features some remarkable brickwork and is set in an Elizabethan garden. The Tudor House is also now a museum of local history. (J. Ounsworth collection)

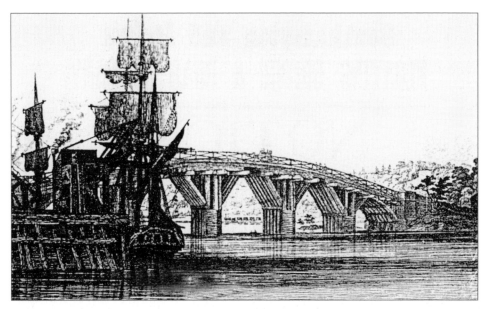

Phillip Brannon's 1850 engraving of Northam's first toll bridge. Southampton's prosperity revived in the eighteenth century when a large influx of people came to the resort. This bridge eased traffic in from the east. The ship is a collier. Coastal trade involved more tonnage than overseas and in 1885 30 per cent of sea-going and 80 per cent of steamships were British. Improved southern railways were drawing trade away from Liverpool.

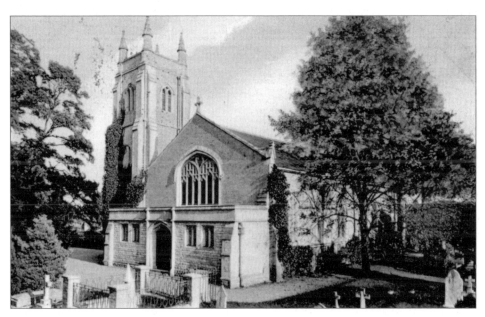

All Saints' Church, Botley. Church played an important civilizing role and another of the churches in the area, St Mary's, found fame through the song it inspired, 'The Bells of St Mary's', which became the theme song to a Bing Crosby film. (J. Ounsworth collection)

Southampton and Itchen
FLOATING BRIDGE & ROAD COMPANY.

NOTICE!

ON THURSDAY MORNING, April 20th, the Bridge WILL BE STOPPED for a few hours after 6 o'clock, a.m. for the purpose of repairing the Chain.

W. G. LANKESTER, *Manager.*

April 19th, 1876.

A. RANDLE, Printing Works, 189 and 140, High Street, Southampton.

The Itchen floating bridge was a kind of raft pulled across the river by chains which were wound by steam engine. Before it opened in 1836 rowing boats were used to cross the river. The Borough Council bought the bridge in 1936 and a high-level fixed bridge did not open until 1977.

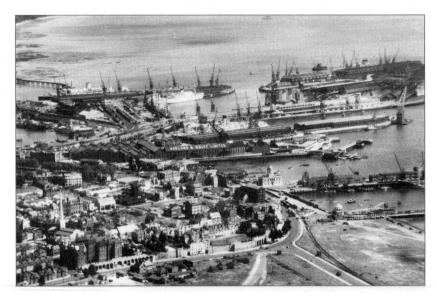

The broad expanse of Southampton Water opens eastwards away from the old docks, which are shown here gradually getting back to a life of peace and normality during the early 1950s. (City Archive)

Highland Water, New Forest. There are no apparent walls here, but from the time of William the Conqueror the common folk were walled in by a ruthless pecking order that overrode their ancient rights. Everything in the New Forest was available only at the king's discretion. Even the king's chosen nobles had to tread carefully, but generally enjoyed a privileged existence as long as they did the king's bidding. (J. Ounsworth collection)

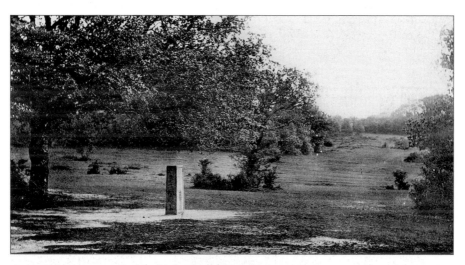

A wise king always watched his back. This is the Rufus Stone, in the New Forest, photographed in about 1927. William II was called Rufus ('red') because of his high colouring. The stone marks the spot where he was killed in 1100 by a fellow hunter's arrow. Suspicions were aroused when his brother Henry quickly rode off to Winchester to declare himself king. Henry is remembered for improving the administration of a law which favoured his own kind. Modern hunting folk might seem to ape the old ways; they too have their accidents, some due to conflict with those who think the continuation of the old custom is barbaric. Police condemned a hundred hunt saboteurs in March 1996 who, wearing balaclavas, physically attacked hunters. But the Hunt Saboteurs Association said the huntsmen deliberately rode their horses over the saboteurs and made death threats. (J. Ounsworth collection)

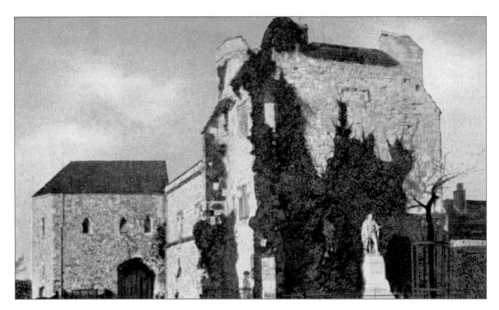

The old prison, *c.* 1907. It was known as God's House Tower because it stood near the twelfth-century foundation of God's House in Winkle Street, which provided alms and hospitality to the poor. Built as an artillery position in the south-east part of town, the tower served as a gaol from 1707 to 1855, before the harbour board took it over as a store. In recent years it has become a museum of archaeology. (J. Ounsworth collection)

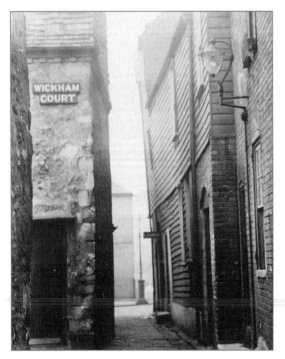

Home Secretary Robert Peel set the standard for other cities when he established the Metropolitan Police. Local government reform gave new town councils responsibility for law and order and Southampton's police force was started in 1836. New constables were urged to be 'cautious not to interfere idly or unnecessarily in order to make a display of authority'. This was difficult in the growing network of cramped courts and crowded backstreets like Vyse Lane, leading to Wickham and Victoria Courts, shown here in 1928. There was a spate of robberies in November 1851, which Police Inspector Benjamin Judd attributed mostly to thieves cohabiting with girls upon whose prostitution they subsisted and 'when that source fails they prefer risks of burglary rather than work'. In 1851 government inspectors estimated that each policeman was in charge of 929 people and 125 acres each night (*see* page 94). (City Record Office)

The 1851 visitors' guide to Southampton said: 'It seems extremely probable that in a few years the whole of the space enclosed by the Test and Itchen south of a line from Northam Bridge to the village of Four Posts (at the bottom of Hill Lane) as well as parts beyond this line will be covered with streets and villas . . . '. In this picture of Cobden Bridge (named after the great free trade campaigner and built in 1883) this process is under way. The Corporation opened the bridge to free public use in 1902 to benefit those living on the Bitterne Park Estate. An iron bridge was built at Northam to compete with it and help traffic flow. By then Woolston's population had reached ten thousand. Trams were a vital link and the old tram body in the foreground served as a passenger shelter.

By the turn of the century Southampton's population had reached some 105,000. Parks and fields disappeared under the flood as housing was carelessly thrown up. Without proper sanitation 'King Cholera' had an easy time wiping out hundreds of people. By 1900 a proper sewage scheme was planned but urban growth outpaced provision. This picture shows Bassett Avenue in around 1907 with land being advertised for sale or let. Land was eagerly gobbled up by developers. Meanwhile Fray's milk float, from Red Lodge Dairy in Rockleigh Road, looks a masterpiece of craftsmanship and not the type that the famous milkman-turned-comedian Benny Hill would have driven. All sorts of comedians drive milkfloats, not least the man who attacked two before riding one bumper-car style around Unigate's Sholing dairy in March 1996. Benny Hill never forgot his experiences as a Southampton milkman and reached the top of the hit parade in December 1971 with 'Ernie (the Fastest Milkfloat in the West)'.

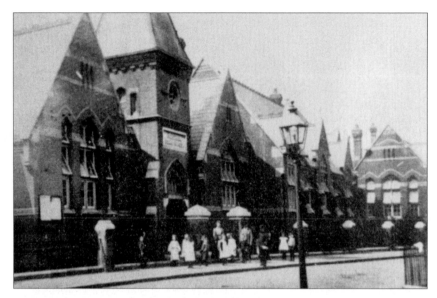

Before formal state education was established in 1870, there were various private educational establishments, including the rather peculiar Hercules Private School of Physical Culture in St Mary's Street — just the thing when brute force was at a premium! The First State Education Act was primarily about educating future factory workers and servicemen. Obedience and piety were the essence. Pupils were taught to know their places. This picture was taken at Kent Street School, Northam, in about 1910.

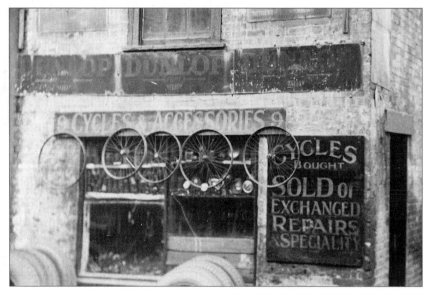

Poverty kept people's minds on the basics, as this shop selling second-hand bike spares in Three Field Lane shows. Cycles were the main form of transport for workmen who would travel long distances on them, especially at the time of this picture, about 1930. (City Record Office)

This is 180 Nelson Place at the rear of St George's Street, Lower Canal Walk, in the early 1930s. Redevelopment, inspired by Lloyd George's wartime promises of 'Homes fit for Heroes' was on the agenda. But money was limited and progress slow. (City Record Office)

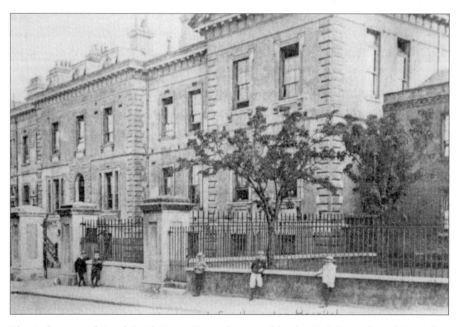

This is the original Royal South Hants Hospital, inspired by the High Street fire of November 1837 and funded by the efforts of the Bullar brothers, both doctors (*see* page 95). Street urchins like those leaning on the wall in this scene, photographed in around 1907, had recently benefited from the addition of a children's ward.

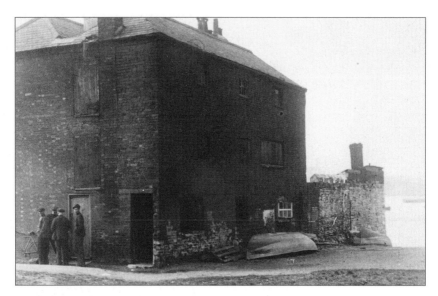

Smiths Quay, Itchen, near the floating bridge, in the early 1920s (*see* page 10). (City Archive)

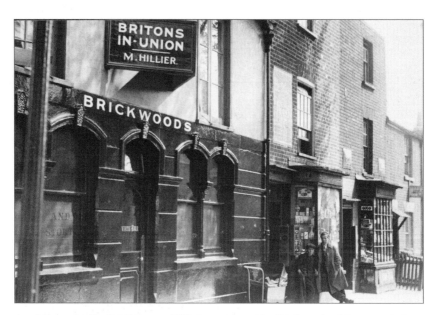

An ale-house in Hartley Street, *c.* 1930. It was owned by Brickwoods of Portsmouth, keen rivals to Coopers, a principal local brewery based near the Bargate. Ale-houses were not licensed to sell spirits and were popular with working-class men eager to blot out their dreary routines. Sadly their escapism deprived their wives of the funds to look after their families, and caused arguments leading to violence. But the brewers grew rich. There were many drinking houses, and even policemen drank heavily. Absalom Simmonds, an ex-watchman promoted to third sergeant, drank so much that in March 1836 he used his pistol to make an arrest; in May he entered a house without authority and in December he assaulted Mrs Wilmott, and was reduced to constable. He would not accept responsibility and was sacked.

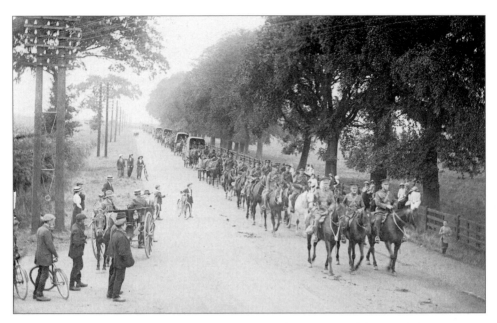

People stopped to watch the nation's heroes heading for the war via Southampton docks. Young men afraid to go were taunted and given white feathers by women who thought carnage a man's lot. Feelings ran high and the statue of Prince Albert, in store at West Quay, was destroyed by angry soldiers camped on the common, where St John's Ambulance provided a refreshment hut. From there the soldiers marched to the docks which were, for all too many of them, their last sight of home. Southampton handled 17,186 ships, 8½ million tons of equipment, 7 million men and a million horses and mules during the conflict. (J. Ounsworth collection)

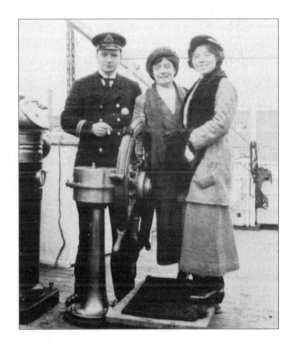

Miss Tebbut (right) with a friend and a young officer posing by the wheel of the Castle Line ship *Grantully Castle,* requisitioned as a hospital ship for the duration of the First World War. Miss Tebbut offered succour to the returning wounded. Around 1¼ million men returned as casualties from the battlefields by hospital ship. This was twice as many as in the less labour-intensive Second World War. Liverpool also played a greater role in the second conflict, reducing Southampton's importance. (City Record Office)

A wounded soldier being stretchered off *Grantully Castle*. Those who condemn all men as if they all love violence would do well to remember how much it has been expected of them in time of war. Many men from Southampton's slums were considered too malnourished, disease-ridden and unfit to shoot or be shot at. Luckily Britain had an empire to call on for reinforcements. Maggie Smith immortalized the sexy songstress seducing young men to be soldiers from her vantage point upon a music hall stage, in the bitterly funny film 'Oh What a Lovely War'. Such recruiting scenes were played out for real at Southampton's Empire Theatre. (City Record Office)

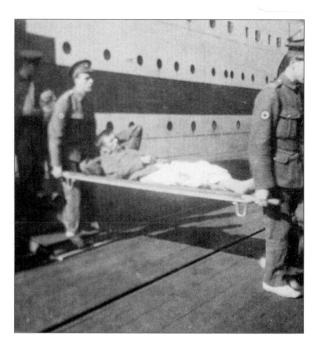

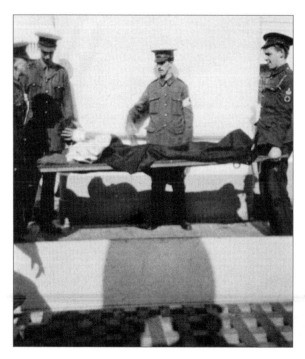

The most commonly heard sound on the First World War battlefields was young men screaming for their mothers. Someone once said that there has never been a man on a battlefield who did not want to be there. That cannot be. After 1916 so many had been lost that conscription became the rule. When I volunteered for the armed forces in 1976 they were at pains to know whether I could kill: 'That's what it all comes down to, Cook,' said the officer. In 1916 they had no choice: 'Your king and your country both need you so.' If you wouldn't go over the top and face death or mutilation you could be shot by your own side. Some men chose the alternative of declaring themselves conscientious objectors and perhaps working like these stretcher-bearers, shown unloading *Grantully Castle*. But even stretcher-bearers were shot at. (City Archive)

The First World War inspired many great poems and songs such as the 'Green Fields of Flanders' from which I quote:

I see by your gravestone you were only 19,
when you joined the great fallen in 1916,
I hope you died well and I hope you died clean,
or young Willy McBride, was it slow and obscene?

For some of these young wounded men may be there was hope, though many were badly injured and life would have been an even greater struggle for those who had to face the post-war depression years as cripples. The wounded are pictured here lined up on the dockside railway platform en route to hospital. (City Archive)

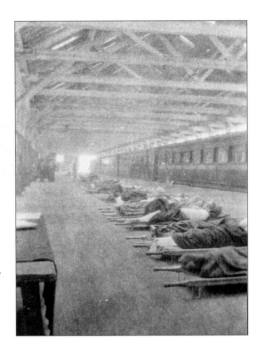

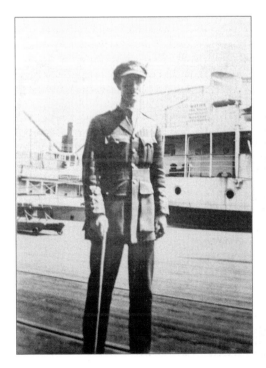

Another First World War song depicted staff officers jumping over each other's back, wickedly suggesting that their war was a game in which they gained promotion at the expense of the 'cannon-fodder' common soldiers. Chief of Staff Field Marshall Haig has long been reviled for his callous attitude, shovelling men on to the battlefields, and playing a numbers game rather than a tactical one. The result was many thousands of lives lost in a few fell swoops. Consequently, young officers scarcely out of training had an average two week life expectancy. This one is lucky, he's got a 'blighty' (a slight wound necessitating his return to England) and has just stepped on to Southampton Docks in 1917. If he's lucky he won't go back. (City Archive)

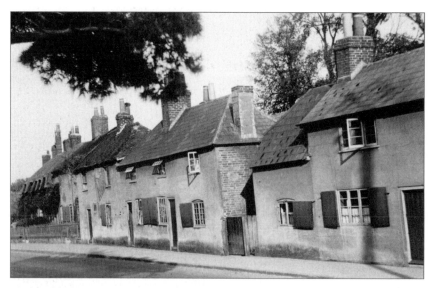

Working-class men lucky enough to return from the horrors of war came back to houses like these in Swaythling High Street. They may look idyllic but this is not the 1980s, the age of 'yuppification' and improvement grants. It is the 1930s and these homes are being considered for demolition. The Corporation had plans for lots of council properties with hot and cold running water. The only problem was raising enough money to pay for them. (City Archive)

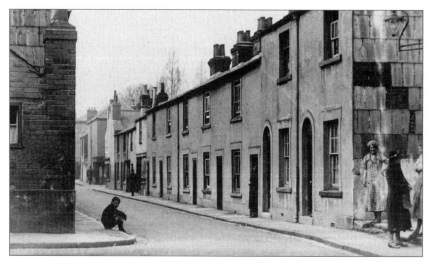

This is Winton Street, in an area ironically called Kingsland. No doubt the menfolk were all kings ruling their poor families with a rod of iron. This 1930s scene reminds me of my own childhood many years later, when I played in the street and lived in a tiny terrace where the loo was flushed with a bucket of water and money worries abounded. Were they happy places? Maybe at times, but the cold and damp got people down and it was easier to blame each other for the misery than anyone higher up. Illness was particularly dangerous for children and giving birth at home was most risky in the days before the National Health Service. But the poor pulled together and somehow survived. (City Archive)

Benny Hill (left) with his family, *c.* 1937. South Coast Minister Ian Taylor shocked some people by being unable to name Benny as the most famous comedian the city has produced. (He didn't say whether he might have been considering one of his own colleagues for the title.) But he admitted to being a Benny Hill fan which doubtless shocked local feminists since much of the Benny Hill Show's appeal was rooted in charming young ladies cavorting around in lacey underwear and black stockings. Apparently Benny personally auditioned his dancing girls and was always dating them, but his greatest pleasure was watching television and videos. He promised his parents he would never sell their Southampton semi, and he kept it until his death in 1992.

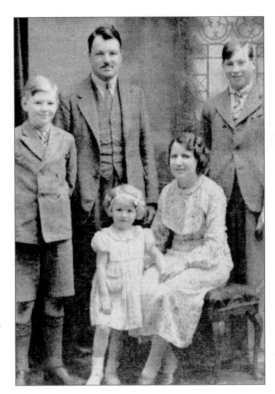

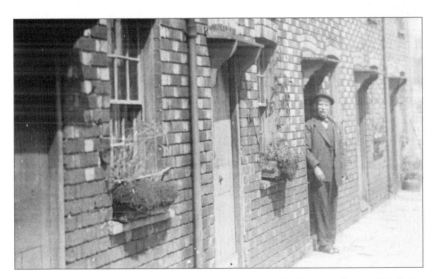

Benny Hill's career waned as political correctness got a grip, but he was still one of the lucky ones, escaping the humdrum life of the milkround and making millions. There was no such luck for this old chap, posing here in Cook Street in about 1930. His greatest pleasure would have been those window boxes and maybe an allotment up the road. It seems strange how much complaining there is today, compared with the bygone days of brutal hardships, when people just got on with it. (City Archive)

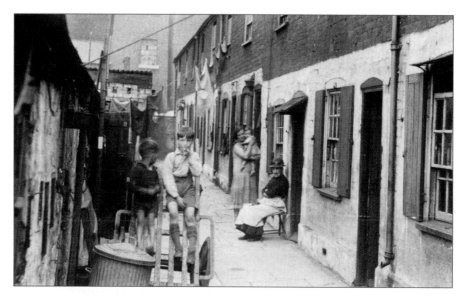

Union Place off Union Court, 1930s. The name was derived from its proximity to the Poor Law Union workhouse. After the 1834 Poor Law Reform, parishes formed unions to spread the cost of caring for their poor in a common building. Conditions within had to be worse than the worst survivable conditions outside otherwise too many people would want to get in! There was hardship right up to the Second World War, but at least Southampton was working to clear slums like these. It is arguable that a more courageous and imaginative government would have followed the examples of Germany and the USA, creating jobs by spending more on public works. (City Archive)

King Street, Three Field Lane area, c. 1933. Which king would have lived here, you might ask? In spite of hardship, families were large and as many as ten children might be crammed into a tiny terraced cottage. Birth control was either disliked, unknown or rejected on religious grounds. Infant mortality rates were high. (City Archive)

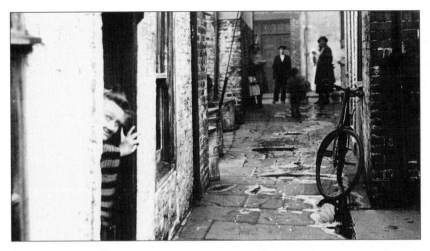

No. 3 Cannon Street, Shirley, in the late 1920s. There's a happy face on the left. They didn't have the lottery then but something seems to have tickled her fancy! Why ever did they call those the good old days? Perhaps it was because you could leave your bicycle unattended for five minutes without having to wrap it in an anchor chain! What did they do in their spare time? One old timer said: 'That's obvious from the number of children they had.' Maybe television is not such a bad idea after all! Southampton's population grew from 7,913 in 1801 to 46,960 in 1861. The St Mary's area grew quickest, from 1,807 to 28,514. (City Archive)

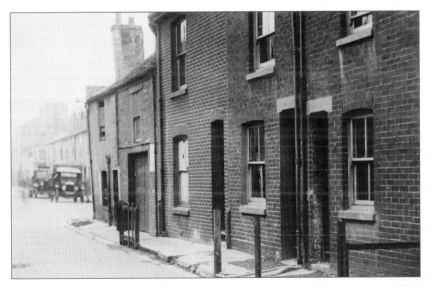

Another street scene in the Three Field Lane area in the late 1920s when the area was earmarked for redevelopment. Crime in those days, according to PC John Arlott, was not such a worry and Southampton was regarded as a 'cushy' job. He recalled the nerve of one burglar who used to approach houses with a rolled-up newspaper. He rang the bell or knocked the door. If there was no reply he thrust the newspaper, which concealed a jemmy, between door and the frame and levered it open. As he entered he raised his hat in case he was being watched. That sounds like enterprise! (City Archive)

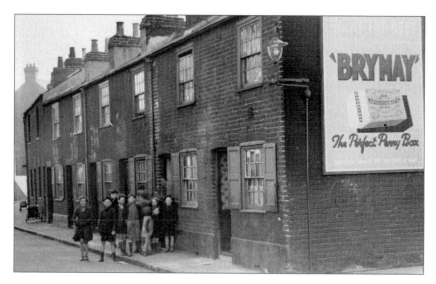

New Court in Grove Street, Botany Bay, in Sholing District, where a tiny terrace fields its proper share of youngsters. 'Brymay' matches were useful for lighting the gas. Southampton Gas Company served a wide area and imported lots of coal to make it. The unlit gas stove was also a way out of life for the poor who couldn't take any more. A slower way out was by lighting up a daily dose of rolled tobacco, though the hazards of smoking were then unknown. (City Archive)

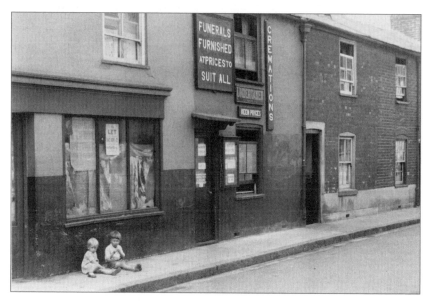

This late 1920s view of the exotically named Cossack Street – a name redolent of the romance of far-away places visited by Southampton sailors – in the Kingsland area, is a reminder of ever-present death. We can see from the undertaker's advert that death wasn't just an all-too-frequent visitor, it was a close neighbour. The year 1924 was a record year for women dying in childbirth. (City Archive)

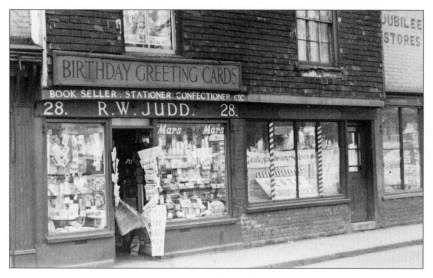

St Mary's Street near Chapel Street Corner just before the 1930s clearances. Publishing boomed during the eighteenth century, but literature was an aristocratic pursuit. Public libraries developed out of late nineteenth-century municipal reforms and workmen's reading rooms further spread the word. Newsagents like this one helped by selling popular fiction and running lending libraries. (City Archive)

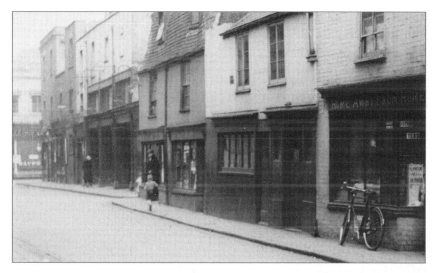

The 'hungry thirties' in Three Field Lane. What's dad got for his boy running to meet him? It's amazing after all the years of progress that there is still so much want. Now there is a plan to demolish whole swathes of St Mary's and the Bevois Valley corridor for rebuilding. Part-time student Steve Texeira thinks more leisure facilities are needed for the young so that they don't get up to mischief, but the area should not just become a student village. Others fear it will become just another shopping centre when housing needs should be top of the list. The housing problem goes way beyond the city. There is an acute shortage of affordable housing in the New Forest in the wake of council house sell-offs. (City Archive)

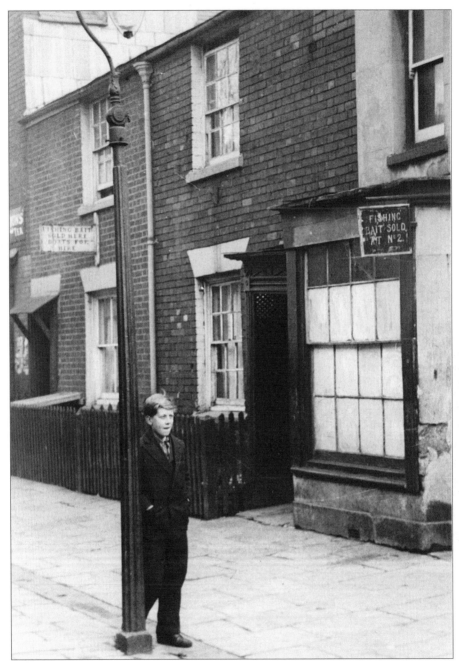

Hartley Street, Lower Canal Walk, before the demolition teams arrived in the early 1930s. Selling fishing bait was one way for inhabitants of this cramped terrace to make some extra shillings. Fishing bait was a euphemism for maggots, which were never in short supply in this neighbourhood. Fishing was and still is the nation's most popular participant sport, but to the poor in those days it was also a way of getting food. This boy leaning on a lamp-post might be fishing for something else, maybe a 'certain little lady' who might go by. (City Archive)

SECTION TWO

BEYOND THE WALLS

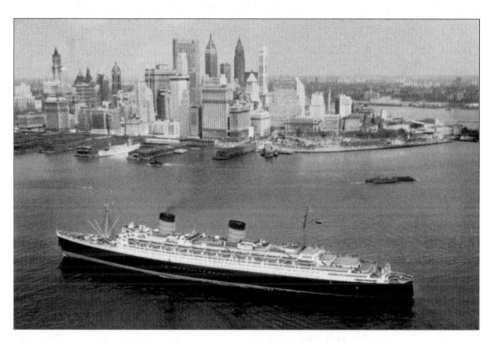

Southampton was for a long time the gateway to the New World, beginning with the pioneer voyage of the Mayflower *in 1620 and continuing into the 1950s with cruise liners like this one approaching New York Harbour. (J. Ounsworth collection)*

Red Funnel's paddle-steamer *Lorna Doone* passes a Union Castle liner in Southampton Docks, with a variety of shipyard and repair facilities in the background, *c.* 1938. Gladys and Ken Eacher recall the pleasure of riding these small boats: 'I liked watching the paddles going round, it was very relaxing,' said Gladys. They were very manoeuvrable, by varying the paddle speeds on either side. Red Funnel was originally known as the Royal Mail Steam Packet Company, and led the field in ferry services to

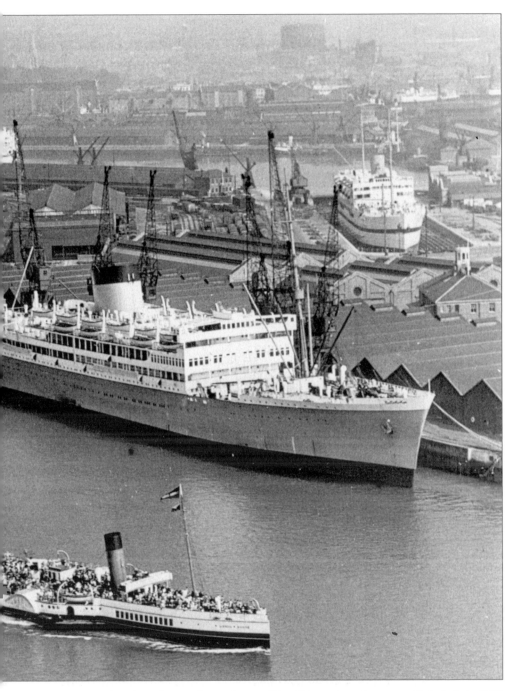

the Isle of Wight and along the south coast. The 427-ton *Lorna Doone* was Clyde-built in 1891 and was brought second-hand in 1898. She was requisitioned and worn out in the war and she was replaced by the *Lorna Doone II*. The Union Castle liner shown carries no name, probably because the Union and Castle lines had just merged and were in the process of reorganizing. (Red Funnel Ferries)

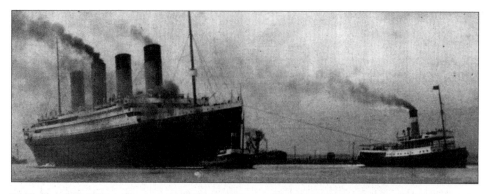

RMS (Royal Mail Ship) *Titanic* is carefully guided out of Southampton by two fussy little tugs at the start of a 3,000 mile journey she was destined not to complete. The loss of a great ship called *Titan* had been foretold in the 1890s but none believed this could be the *Titanic*. Millionaires set the pace on board, sending messages ordering limousines and arranging parties in New York. Perhaps this diverted attention from the weather reports. Poor Irish emigrants, collected en route, were locked below when the ship hit an iceberg and began to sink – because there were not enough lifeboats. Hundreds drowned.

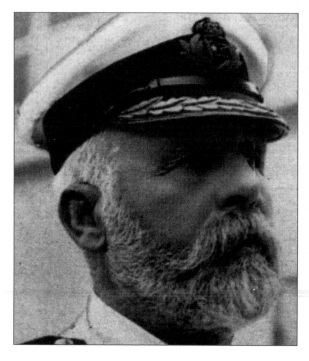

The *Titanic*'s captain, Edward J. Smith, was near retirement when he took command of the White Star flagship. Many of the drowned seamen came from Southampton and their families were left to mourn. Robert Hitchen was a Southampton crewman who was at the helm when she struck. Having survived the disaster, he later served a prison sentence in South Africa, after killing a man. Great efforts were made to clear Smith of blame for the loss of the *Titanic*; ironically, he was finally cleared by an enquiry in 1987, after the loss of the *Herald of Free Enterprise* – a tragedy that was initially blamed on a seaman for not closing the bow doors, rather than on the company's undue haste to turn their ship around. The fact is a captain is paid to take command and Smith recklessly allowed the *Titanic* to speed through an ice field.

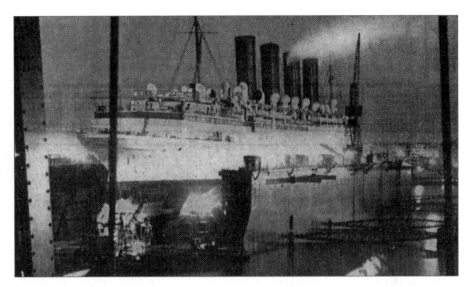

A world trade depression in the 1930s meant there were too many ships. From 1930 to 1935 many owners were forced to sell vessels to ship breakers or foreign owners for a mere song. Many of these ships then ended up competing with British trade because of their lower operating costs. British tonnage fell from 20,184,000 to 17,600,000. Other countries did not prune so vigorously. From 1931 to 1935 world tonnage decreased by only 4,365,000 tons. This picture shows the liner *Mauretania* entering dry dock for the last time in Southampton in April 1935. (J. Ounsworth collection)

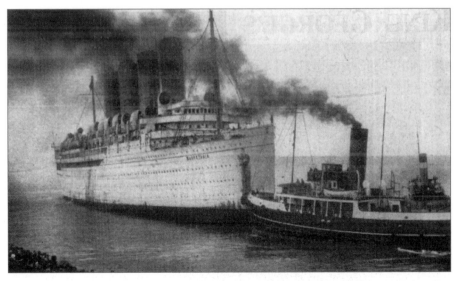

Mauretania leaves Southampton for the last time on 1 July 1935, en route to the breakers at Rosyth. Since 1907 she had steamed some 2½ million miles between England and America. The *Canberra*, now thirty-five years old, seems likely to suffer a similar fate. A stalwart of the Falklands War, her owners are reluctant to make costly structural changes to meet 1997 safety standards when she returns from her final cruise. (J. Ounsworth collection)

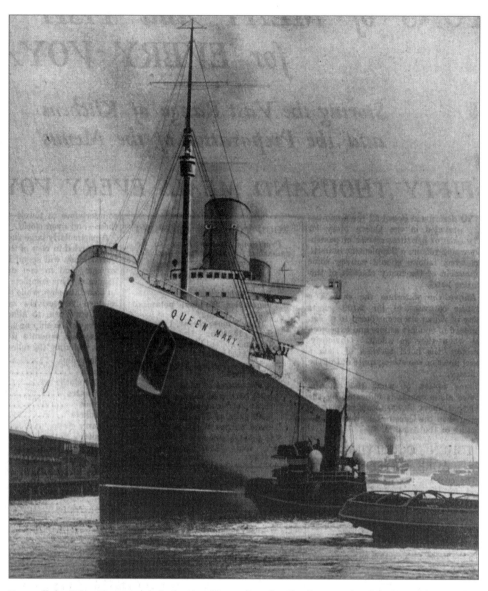

Tugs pull the *Queen Mary*, a symbol of national hope, from her Southampton berth in May 1936. Another great liner, the *Queen Elizabeth,* was already in the Clydeside pipeline. The government provided a large share of the building costs for both ships on condition that Cunard and the White Star line merged. Seaborne trade had not increased since 1910 but world shipping tonnage was up by 20 million tons. Great liners like the *Queen Mary* took people's minds off harsh realities; they were the stuff of dreams and the five hundred VIPs who headed south to enjoy her first official trip thought only of her opulence. Sixty towns contributed to her building, with Southampton supplying the diesel engines. She boasted a long gallery with twenty-two large windows overlooking the promenade deck, a light and delicate effect to the woodwork using *betula* (birch) wood throughout and a large swimming pool on C deck. Decorations included a Sussex landscape entitled 'Evening on the Avon' by Algernon Newton ARA. The *Queen Mary* recaptured the treasured Blue Riband for Great Britain on 31 August 1936, for the fastest crossing of the Atlantic at an average speed of 30.7 knots. (J. Ounsworth collection)

In the mid-1930s owning a car was a status symbol. Being able to garage it at Southampton while you were off cruising was a sign of even higher status. This advert was aimed at the motoring élite of 1936. (J. Ounsworth collection)

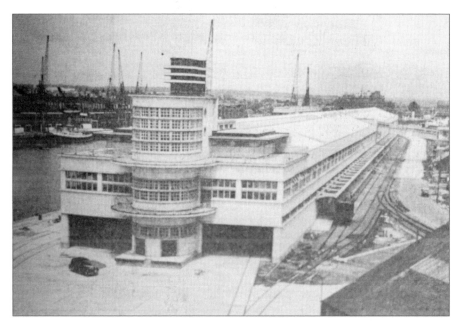

Southampton's Ocean Terminal, a symbol of Britain's post-war optimism toward the cruising industry. Sadly for sentimental lovers of style, the embryonic airline industry would soon destroy all that and the cruise fraternity would be too small to sustain this kind of facility. Lasting little more than two decades, it was an old-fashioned world of splendid gangways, lavish waiting halls with a buffet and car park – though in the beginning 80 per cent of travellers arrived by train. One of the 'Queens' would come in on a Monday and sail at about midday on the following Thursday. Pullman trains ran straight into the terminal. Before the Second World War first class travellers stayed over at the South Western Hotel.

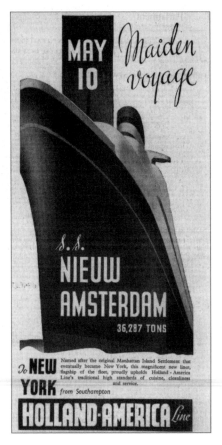

Above: One of the advertisements from well wishers bidding the *Queen Mary* 'bon voyage' in 1935. Memories of the great ship came flooding back on 24 May 1996 as her deep-throated sirens were heard blasting out from Ocean Village across the old docks that she had left for the last time on a grey day in October 1967. I was lucky enough to be on Western Docks at the time and the sirens were as of a ghost, having been taped in California where *Queen Mary* is 'retired' to service as a hotel and leisure centre. The sirens were intended as an opening fanfare to a week of events marking the week of her maiden voyage.

Left: The advert speaks for itself. Competition for transatlantic trade was very keen during the 1930s.

Neville Chamberlain, Chancellor of the Exchequer (left), Lord Derby (centre) and Lord Swinton, the Air Minister, chatting on Waterloo station just before the 'Queen Mary Special' left for Southampton on 14 May 1936. The train was arranged for VIPs to join the ship's first official voyage. One who almost missed the boat was Tarleton Winchester, the European manager of the United States Lines. He dashed up to the quayside in a taxi only to see the liner heading down Southampton Water. Having been detained in London on business, he had had to travel to Southampton by road. But officials came to his rescue by calling a tug to carry him after it. There were cheers and smiles as the tug overtook the liner and Tarleton Winchester was able to climb aboard. (J. Ounsworth collection)

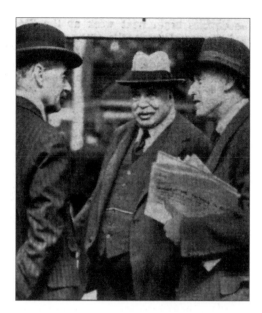

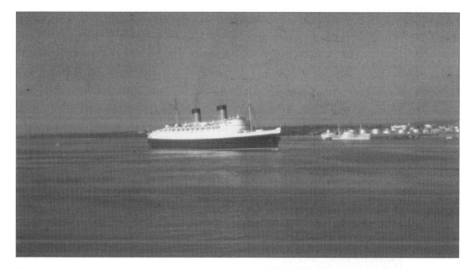

The *Queen Elizabeth* passing Fawley oil terminal in 1963. The liner had not been in service very long before being adapted to war needs, and by the time she got back to cruising the industry was in decline. Cunard worked hard to rekindle the flame and launched the *Queen Elizabeth II* in September 1967. *Queen Mary* retired in the same year. Newcomers to the industry sought a mass market for cruises and profits were squeezed. The days of gracefulness were giving way to the age of push and shove. Such has been the pace and manner of events that on 3 March 1996 the *Financial Mail* announced that Mickey Mouse could soon be captain of the *QE2* because Walt Disney Enterprises were interested in buying the liner. Cunard made a £134 million loss during 1994/5. But Paul Beaufrere, a leading analyst, suggested that the company could be worth £500 million with the right marketing – so much these days comes down to image. He noted that the principal ships, *QE2* and *Royal Viking Sun*, may be old but they are well refurbished. (K. Eacher)

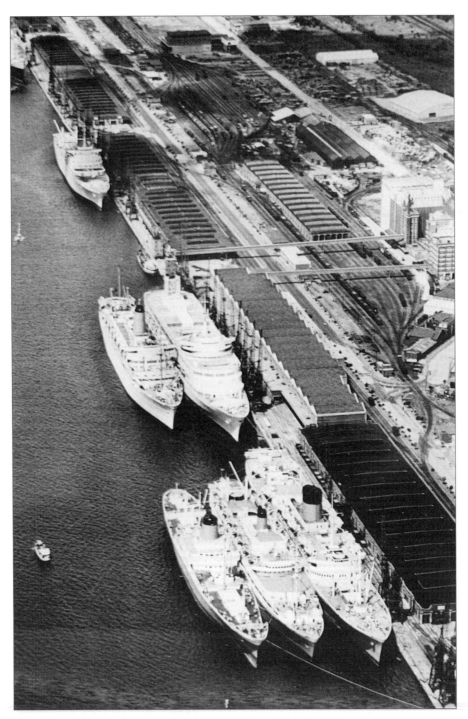

Western Docks in the mid-1950s, complete with shining railway lines and Solent Mills prominent on the right. Southampton is a leading exporter of grain, shipping out over a million tons yearly. (Associated British Ports)

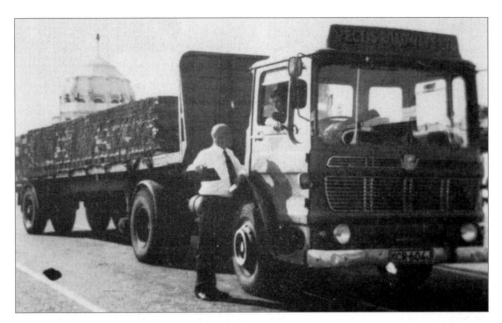

A layer of brick-earth runs through Hampshire, about 3 ft below the surface, and was the backbone of many small-scale brickmakers. But in 1888 a discovery at Fletton near Peterborough changed the way bricks were made. Clay extracted from 90 ft below the surface was used for bricks for the first time when high-power steam presses became available that were powerful enough to shape the exceptionally hard clay. This clay contained a lot of carbon and only needed small amounts of additional fuel to start and control the baking (burning) process inside the multi-chamber Hoffman kilns. Heat from a burning chamber was passed forward to the next chamber so as to get the bricks dry and ready for burning as soon as the previous lot was ready. The cost of brickmaking plummeted and Flettons began to dominate the mass housebuilding supplies. The London Brick Company, based mainly in Beds and Bucks, was the principal supplier of Flettons, and this picture shows some of their products being checked on the Southampton quayside in August 1976 before being taken across the Solent to the Isle of Wight.

The bricks were safely on board the *Norris Castle* and all set for the Isle of Wight, which has seen considerable population growth during the post-war period. The island used to have its own brickworks – the Rookley Brick Company – but this closed in the recession. Flettons were originally sent there by rail from Stewartby to Southampton and loaded into barges, but using contractors like Vectis Transport reduced handling times.

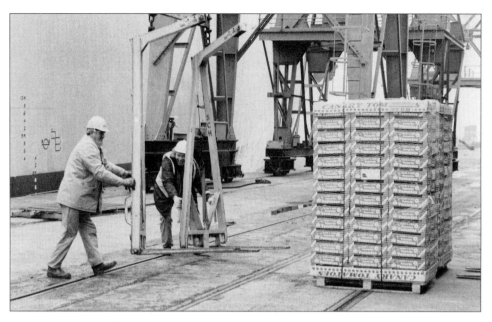

Dockers unloading tomatoes at Western Docks, March 1996. Times have changed for seamen and dockers. They are a long way from the heady days of socialism. In 1887 thirty-three ambitious young coal porters started a Co-op grocery shop in Melbourne Street and had 2,300 members by 1906. Merchant seamen, too, did their bit for socialism's history. Ex-Cunarder John Prescott made the news during the 1966 seamen's strike and swapped careers for full-time politics – now he is deputy leader of the Labour Party, confessing that he is middle class. He is a man of foresight. Docker and ex-sailor Derek Cooper (right) said: 'The age of the British seaman is over.'

A young Filipino seaman on Western Docks steps out to test the temperature of tomatoes on the quayside in March 1996. Docker Derek Cooper observed: 'Filipinos are crewing nearly everything. They work for much lower wages. Only the officers are British these days.' Meanwhile their old comrade John Prescott returned in the same month to launch Labour's fight to keep control of the City Council. He was speaking at Hulse Road Social Club in a warm-up to the general election campaign, alongside Itchen MP John Denham, while left wingers made silent protest on the pavement outside over the admission charge of £2.50. (Labour later abandoned a plan to subsidize shipping companies using British seamen.) (R. Cook)

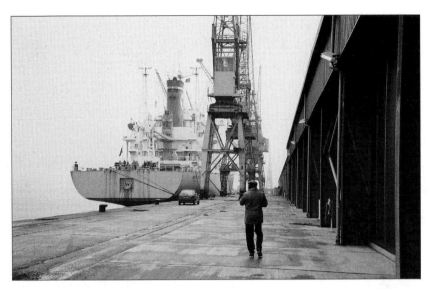

Local magistrate Vernon Church hunches up against the cold on Western Docks, March 1986. He joked about coming over from his native Trinidad on a banana boat in 1962 and planning to go back on one. Southampton was the first sight of Britain for many immigrants from the Caribbean and there is a thriving club for expatriates and second-generation West Indians, based in a converted church in St Mary's. (R. Cook)

A&P ship repair yard and dry dock. This yard successfully tendered for the £12 million refit of the *QE2* in May 1996 and the SS *Norway* a few days later. The *Norway* is based in Miami, offering year round Caribbean cruises. She crossed the Atlantic for the first time in twelve years in September 1996. *Norway* was the last French-built superliner and she was launched on 11 May 1960 by President de Gaulle's wife (*see* page 122). (R. Cook)

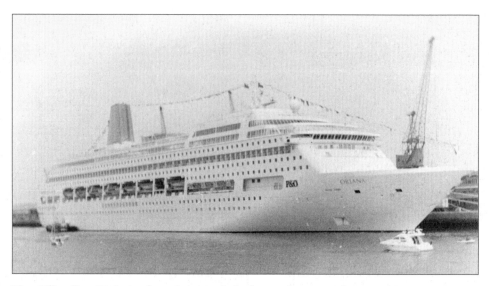

The £200 million P&O superliner *Oriana* ready for her maiden voyage from Southampton in January 1995, but without her replacement propellers. Passenger Winifred Rees, aged 83, paid £20,000 for a three-month cruise and said: 'It sounded like a thousand motorbikes revving up in the Oriental restaurant at the back of the ship.' (M. Hudson)

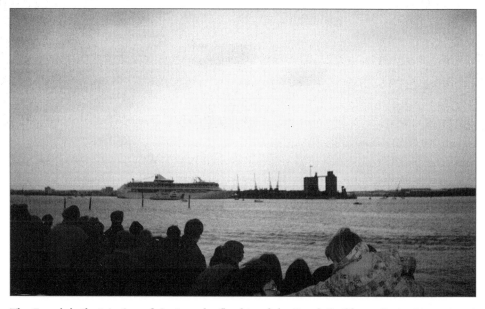

The French-built *Splendour of the Seas*, the flagship of the Royal Caribbean Cruise Line, viewed from near Hythe in March 1996. Solent Mills in silhouette contrasts nicely in shape with the ship's ultramodern outline. The 69,000-tonne liner has eleven passenger decks and carries up to 1,804 passengers. Dubbed the 'ship of light' because of its 2 acres of glass, *Splendour of the Seas* came to Southampton for a naming ceremony that gave hope that the port may remain one of the major cruise capitals. (V. Church)

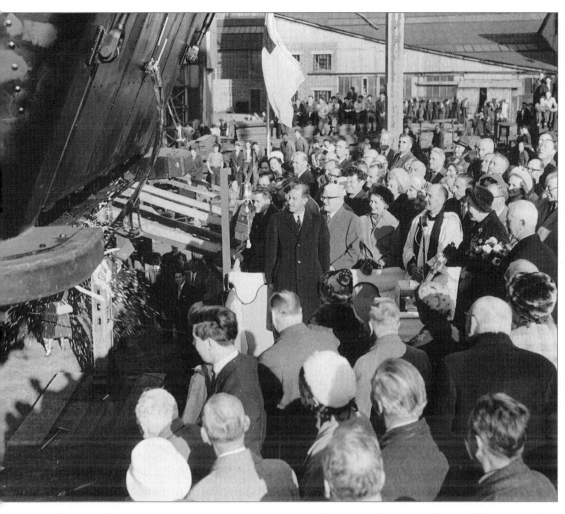

Southampton launch of Red Funnel's *Osborne Castle*. From their 1970s high point of a 40 per cent market share of Isle of Wight trips, the company slumped to 14 per cent in 1989. Now they have fought back to 26 per cent and have a fleet of three superferries and two Red Jet catamarans for high-speed service on the longest route from the mainland to the Isle of Wight. (Red Funnel Ferries)

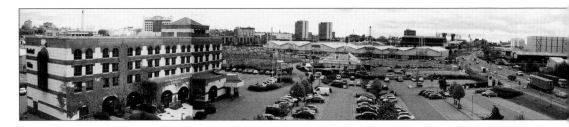

The new city skyline viewed from Novotel in 1996. The large building on the left is the Ibis hotel, part of the modern face of a hotel trade which for many years did not meet post-war demands, Hotel expansion has been concentrated in the old dock area where land has been reclaimed. The city is still criticized for its lack of good restaurants though one novelty is a converted church opposite the Mayflower Theatre. Arthur Fromer's *Dollar Guide to England* in 1979 noted: 'A generally bad run of restaurants and sloppy cooking. . . . Defer your judgement of English food until you have left the port.' He did list some exceptions. (R. Cook)

Research into elephant behaviour revealed much similarity with humans'. Hunting leaves many orphans and the males, lacking the group's normal caring structure, become seriously delinquent. They can undermine the whole group structure, and their violent acts have included the attempted rape of a rhino. Therefore, as our socio-economic system sees fit to discard traditional male skills and virtues at almost a moment's notice, it seems hardly surprising that some young men cause problems. These are getting in the way of traffic in Millbrook Road in March 1995, forcing their services as windscreen cleaners on hapless motorists. Some people might call them entrepreneurs! (R. Cook)

SECTION THREE

LEST WE FORGET

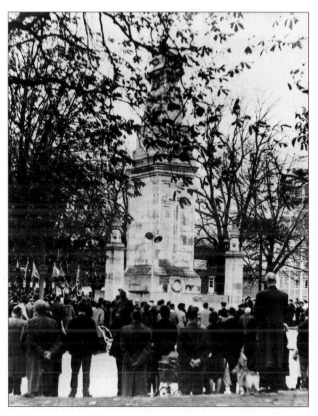

A remembrance day service at the city centre war memorial, 1959.
T.S. Eliot, a frequent traveller by Cunard liner, observed that Germany
and Japan brought to a crisis a sickness which infected civilization,
and their defeat left it not cured but raging. (City Archive)

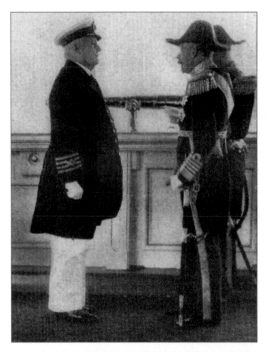

The Royal Navy Review off Spithead, King George V's Jubilee, 18 July 1935. The king is meeting representatives of the British merchant navy on board the Royal Yacht *Victoria & Albert*. Hitler then had been German Chancellor for two years and Britain was playing down its anxiety. The review gave an opportunity to display our firepower and stoke up confidence. Merchant sailors were a less obvious force to be reckoned with. Martin Blane, sunk en route to India, witnessd their heroics and said: 'The decline of the British merchant seaman is sad considering what they did in the war.' Meanwhile back at the Jubilee, Gladys Eacher remembers: 'We had a bun fight in Cadnam village,' and her husband Ken recalls: 'I was in the scouts. We did a little ceremony raising the Union Jack, and paraded through the village. We marched out to Romsey to beef up their party. Every little village around Southampton had something going on.' (J. Ounsworth collection)

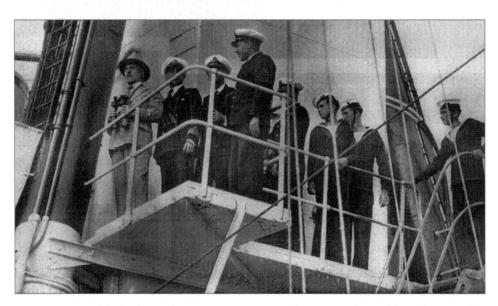

Ramsay MacDonald, the first Labour prime minister – who was condemned by ardent socialists for joining the Tories in a National Government during the depressed 1930s – rubs shoulders with royalty to watch fleet manoeuvres off Spithead in July 1935. It all looked rather impressive but there were still too few people taking the new German leader and his rearming seriously. Technically, the 1919 Treaty of Versailles forbade German rearmament but leading British politicians preferred not to rearm themselves. Bitter memories of the First World War encouraged this attitude, and few wished to believe the worst. They failed to recognize Hitler's hunger for revenge. (J. Ounsworth collection)

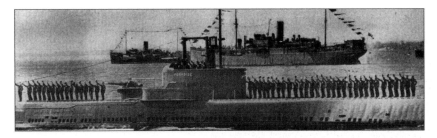

Spithead's 1935 Review was an occasion for fireworks and much singing, such lines as:

We'll still make 'em fear and we'll still make 'em flee,
We'll drub 'em on shore as we've drubbed 'em on sea.

And so there was created a mood of confidence and perhaps complacency among the south coast revellers. After all there was still an empire to call on and much to celebrate, well into that summer night. But British hardware was hard pressed when trouble started and Churchill had to go cap in hand to the United States for equipment under the Lend Lease arrangement, and ultimately American troops proved crucial. But the price was near bankruptcy and pressure to relinquish the empire. Britain stood very much alone when it came to making peace. (J. Ounsworth collection)

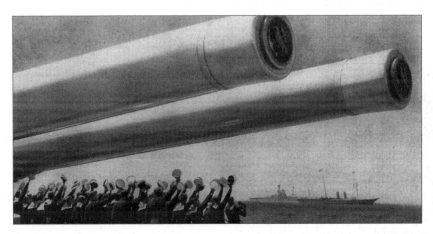

His Majesty's yacht *Victoria and Albert* pauses on the horizon while cheering sailors cluster under the mighty guns of the ill-fated HMS *Hood* off Spithead in 1935. War was approaching and Britain would regret pruning all those surplus ships (*see* page 31) and British shipyards would be overworked replacing them. Thornycroft received orders for four destroyers when the conflict became inevitable and the Woolston yard was kept busy until the peace as Britain's third largest supplier of destroyers. It's all different today. The government announced on 28 February 1996 that the company, now Vosper Thornycroft, would not be building the last batch of Type 23 frigates. The *Southern Daily Echo* reported a desperately sad and traumatic day for management and craftsmen alike, noting that its ripples would spread and seep into the lives of families and businesses in and around Southampton. Fortunately, the company is more appreciated overseas; it supplied a corvette to the Royal Navy of Oman the following March and is tipped for more orders. Their trimaran warship received its Far East debut in Kuala Lumpur. (J. Ounsworth collection)

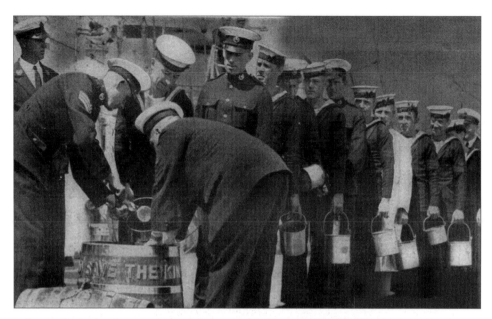

Sailors at the Spithead Review in 1935, queueing for their rum ration. In the old days, the rum was issued to bolster the men's spirits in times of battle. (J. Ounsworth collection)

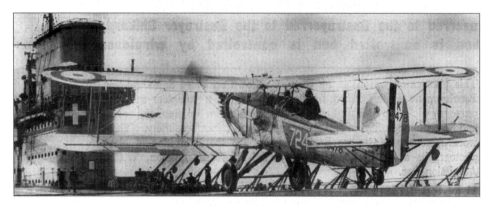

A Fairey Swordfish ready for take-off from the deck of HMS *Courageous* at the Spithead Review, July 1935. My late colleague John Negus began his career as a seaman and fought wartime fires on Southampton Docks. He was relieved to get above it all flying a Swordfish with the Fleet Air Arm and thrilled me with tales of flying these old bone-shakers. He reckoned they weren't quite up to it. One of his colleagues was the actor Laurence Olivier who, John said, 'wasn't much interested in the war and wanted to get back to acting'. One wonders whether the same might be said for some of the politicians. On 15 December 1939 the Fleet Air Arm asked for fifty Spitfires with folding wings and arrester gear to be built. Supermarine returned drawings of a Griffin-engined variant with a delivery time of eleven months. On 2 February 1940 the Admiralty asked the Air Ministry to sanction the order. The Ministry declined, saying it would cost the output of two hundred standard Spitfires and that they should make do with what they had – mainly old biplanes. The Navy waited two years for converted Spitfires while Fleet Air Arm pilots were recklessly sent out in their slow old biplanes to try to sink targets like the three German pocket battleships. (J. Ounsworth collection)

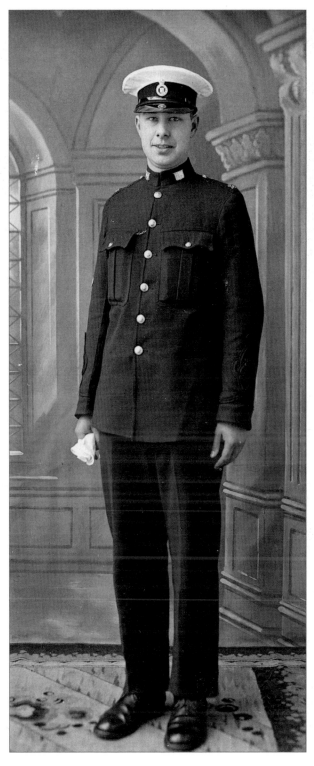

Police Constable Bertram Adams pictured early in his career, just before the Second World War. Bertram said: 'I served with John Arlott. Everyone agrees he wasn't cut out for the police force and there were many times we got him out of trouble. He had lodgings in Silverdale Road near the Dell football ground. On early morning parade we'd have to go round and pull him out of bed. But no one could touch him for knowledge of cricket and he spent a lot of time at the county ground. Someone said to him: "What do you know about cricket, you're no bloody good at it." So he said: "I consider myself a better judge of the egg than the chicken that laid it." We wore flat caps, not helmets, when I joined the Southampton police. Then I went in the Navy and wore another flat cap. After the war the force went over to helmets but I was promoted to detective constable on my return and, unusually, straight on to detective sergeant. So I always wore a flat cap.' (B.A. Adams)

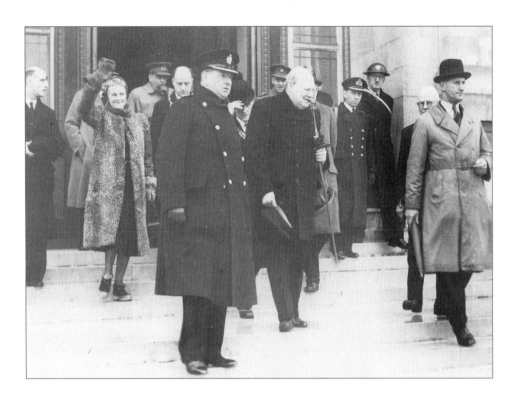

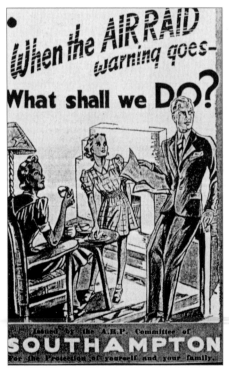

Above: A report for the Home Intelligence division of the Ministry of Information in December 1940 noted: 'The instinct for home and local associations remains and the feeling of despair about Southampton could surely be reduced by local leadership, propaganda and some brighter touches.' And who better to get the ball rolling the following January than "Mr Propaganda" himself, Winston Churchill. Here he is visiting the city centre at a time which Joyce Adams still remembers vividly: 'You'd walk round the corner wondering if your house was still there.' (*Southern Daily Echo*)

Left: 'When the air raid warning goes – what shall we do? asks this Ministry of Information poster. But who could they look to for guidance? The truth was that the nation had been poorly led for years leading up to the war and the city itself was ill-led through the thick of it. (City Archive)

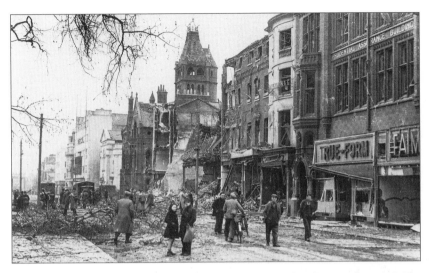

There was incessant bombing of the city in late November and early December 1940. The Bishop of Winchester commented: 'For the time morale has collapsed. I went from parish to parish and everywhere there was fear.' Ken and Gladys Eacher remember watching from the New Forest side of the river: 'It was just solid fire, a terrible sight, but there was nothing you could do.' Ken remembers the pathetic tribe carrying their possessions on the road to Romsey as he returned home from work at night. Gladys says she will never forget the smell of burning hanging on the city air the morning after a raid. (*Southern Daily Echo*)

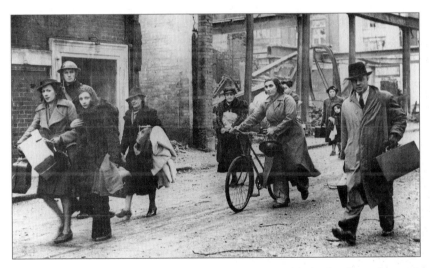

People on the nightly trek out of town to escape the inevitable fire bombing. They took what little of their possessions that they could carry. Mass Observation was an independent opinion-polling organization that reported to the Ministry of Information on 9 December: 'The strongest feeling in Southampton today is that it is finished. Many will not say this openly, but it is a deep-seated feeling that has grown in the past fortnight. Yet many householders continue to come in every day, and quite a number of women spend the day in their homes and the night in outlying billets – even as far as Salisbury.' (Imperial War Museum)

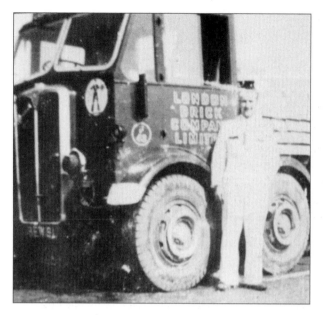

London Brick Co. lorry driver Harold Oldmeadows with his vehicle, its headlights adapted for the blackout. Most of the company's vehicles were requisitioned in the war. At first they carried bricks for war installations such as street shelters, then they were used to carry various war materials including Spitfire parts to and from Southampton and the docks. Jimmy Price remembers driving his blazing vehicle along the dock roads during heavy raids. (Pam Rayner)

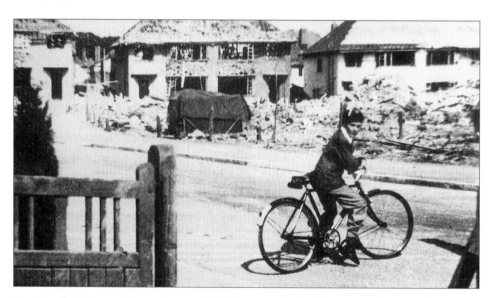

The first slum clearances began during the 1930s as part of Lloyd George's promise of 'homes fit for heroes'. Sadly, not enough were built and those that were became Hitler's targets, as we can see from this 1940 suburban scene. Bertram Adams recalls: 'The Germans perfected the technique of dropping high explosives and incendiaries together. They thus blew up the water mains so that firemen stood helpless against terrible fires.' His wife Joyce remembers: 'I was 21 and remember going up in the roof with dad and tipping sand from a bucket on to an incendiary. Sometimes we had to run to the shelter in the garden. We had dug it ourselves. If a bomb had hit it direct we'd have had no chance. It was dank and horrible down there.' Much new housing had to be built after the war and much was high-rise. At least the tower blocks had asbestos fire-proofing, but this proved a mixed blessing as workmen rewiring innocently drilled into it. (City Archive)

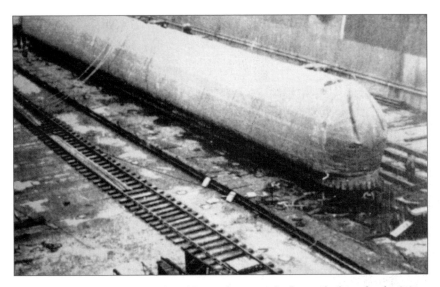

One of Robert Lochner's 200 ft long lilos used as part of a floating harbour for the D-Day landings. He started experimenting in a pond with his lilo mattress, aided by his wife who simulated waves with a biscuit tin and eventually fell in! His genius might have been wasted had an admiral not wondered how a young RNVR officer featured in *London Life* magazine could be commanding a minesweeper if he had to wear such strong glasses. Lochner was called to port for an eye-test which consisted of looking from a window at a large street advert for Gold Flake cigarettes. Unable to identify the colour of the advert he was transferred to the Department of Miscellaneous Weapons. By 1943 he had realized that waves exerted their force over a relatively short depth and so the Bombadon floating breakwater became a reality: his department was nicknamed the 'Wheezers and Bodgers'. (R. Dickins)

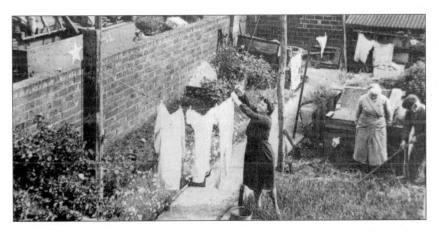

I expect this housewife would rather have been hanging out the washing on the Siegfried Line, but she had to make do with her Southampton backyard. Meanwhile, grandma watches grandpa digging for victory. Over the garden wall American troops clog the highway with hardware ready for the invasion of Europe. Joyce Adams recalls: 'The Americans were very respectful to us girls. They gave us chocolate. We gave them things from the garden.' During the six days following D-Day, 100,000 men were carried by rail through Southampton.

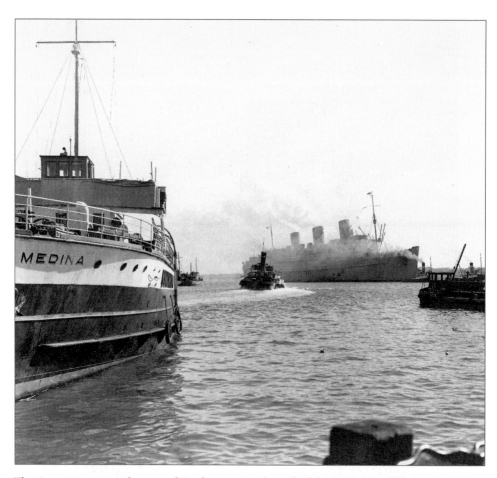

The *Queen Mary* enters the port of Southampton at the end of the Second World War. This had not been a safe place during hostilities as she was a prime target. Once at sea she had the advantage of speed. Southampton policeman Bertram Adams joined the Navy in 1941 and sailed on her to New York, heading for Seattle to commission a ship. He recalls: 'It was a great experience. Rationing was well under way at home so I enjoyed tasting white bread again. But the ship was crowded with twenty thousand troops – it was only designed for two thousand passengers. She was completely stripped out. The first class lounges and ballrooms were full of bunks. We had lifeboat drill every day but nothing could catch us once we were under way. It was in port we were vulnerable. When we got to New York Harbour there was a band playing. You only had to stand on a street corner over there, wearing a British uniform, and a car would stop and offer to take you to places for entertainment.' In this 1945 scene, the great lady is home again in Southampton after her long exile. Still painted in stark battleship grey, she has come to collect American servicemen and British GI brides. The Second World War tested Southampton's trooping facilities to the limit. For the duration it was a focus of enemy interest and streams of wounded men passed through it. Many schools and large houses became temporary hospitals. Marchwood Priory dealt with burns while Netley military hospital dealt with some of the worst cases. Temporary buildings were erected in the grounds. Martin Blane, an RAF airframe fitter, was lucky enough to return unscathed. He remembers the day: 'We came back on a Union Castle liner, the *Arundel Castle*, and anchored off the Isle of Wight. I remember thinking how green it all was after the parched conditions out east. It was March 1946 and early evening. A lot of men were throwing their tropical gear overboard.' (Cunard Archive, University of Liverpool)

SECTION FOUR

FREEDOM

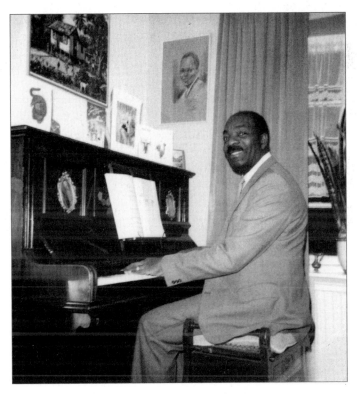

Local magistrate Vernon Church taking his mind off law and order to enjoy the freedom of the keyboard.

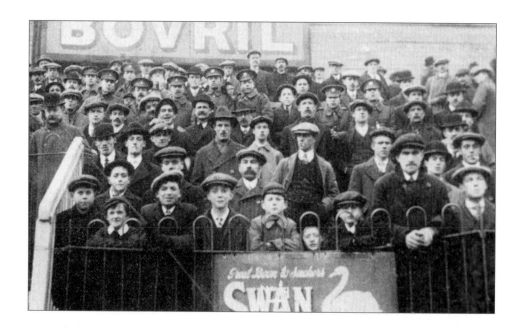

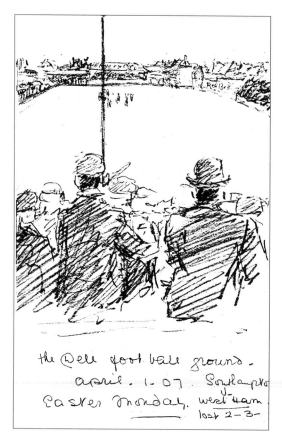

Above: The crowd at the Archers Road end, The Dell football ground, March 1915. It was stalemate (2 all), like the war then raging across Europe. A few lucky uniformed heroes take time off here to enjoy the match; all too soon they would be returning to the slaughter. Freedom has a high price, but is often no more than the recognition of necessity.

Left: This sketch from April 1907 encouraged City Archivist Andrew George to comment: 'Not a lot seems to have changed. They're still all bunched up in mid-field!' Southampton is still a small homely club, whose 15,000-capacity ground is dwarfed even by teams like Port Vale and Huddersfield, let alone the premier giants. Glory days include winning the cup in 1986 under the guidance of the unforgettable Lawrie McMenemy. (City Archive)

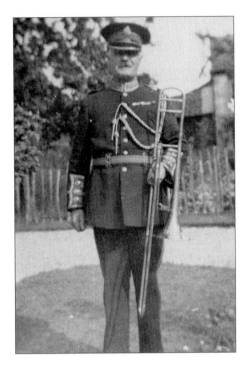

My great-great-uncle Thomas Walker, who migrated from his native Buckinghamshire early last century, settled in Cadnam where he was a member of the local band. Brass and silver bands were a popular form of entertainment in the pre-electric music age and they were just the sound to stir the people's hearts in time of war. (G. Eacher)

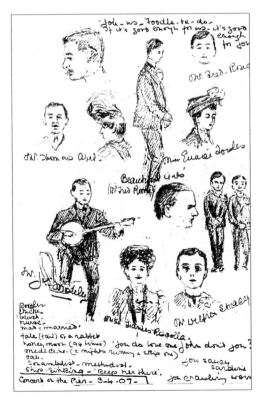

This extract from a local artist's sketch book of about 1907 contains some interesting references to local and home-made entertainment, particularly on the Royal Pier. The pier dates back to the great shipping days and sixteen-year-old student Jonathan Quale is campaigning to get it restored to its former glory. Built on 4½ acres of tidal foreshore at a cost of £42,000, with ten steamer berths and a bandstand, it was the largest steamer and pleasure pier on the south coast. (City Archive)

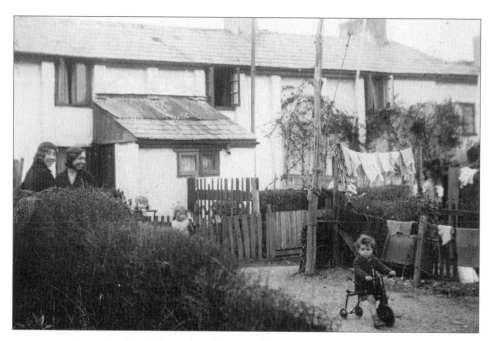

Botany Bay, Sholing, *c.* 1930. The young ladies seem pleased enough just to watch the child ride a trike. In those days there were no labour saving devices to get their washing done, but doesn't it look clean out there blowing on the line – all thanks to hard work, a copper wash boiler and Sunlight soap. (City Archive)

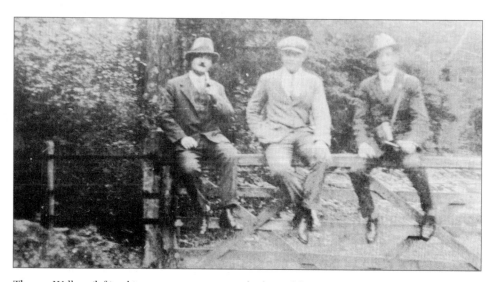

Thomas Walker (left) taking a rest on a gate in the beautiful New Forest countryside just outside the city, *c.* 1920. He is pictured with two of his relatives over from Australia on holiday. They had emigrated down under via Southampton in about 1907, having prepared for the needs of a new world by studying hard at Southampton in night schools. Southampton gained government recognition as an embarkation port in the 1860s and this increased city prosperity. (G. Eacher)

The nearest overseas port of call was the Isle of Wight just across the Solent. Developed as a resort in the nineteenth century, it is still rather quaint, and to Victorians it represented the best of England in miniature. A good railway system was developed from the early 1860s and there were plans for a tunnel link across to Southampton. Fortunately for ferry operators like Red Funnel, it never came. (J. Ounsworth collection)

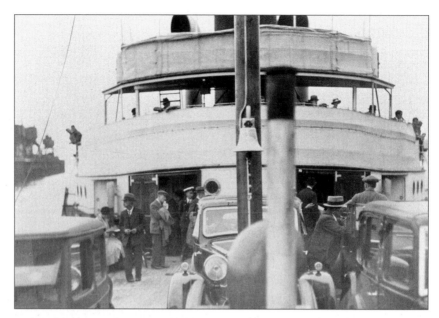

Cars were in the ascendant even in the 1930s when road deaths were nearly double their present level. Here the monstrous creations have a place on one of the first-ever car ferries, Red Funnel's *Princess Elizabeth*, ready for the Isle of Wight run in about 1938. A wheel house was added to this part of the boat after the war. (Red Funnel Ferries)

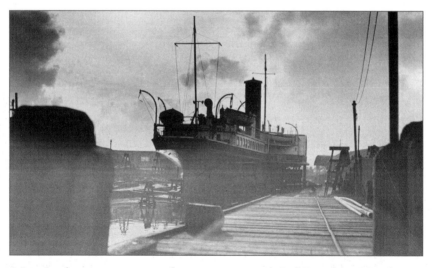

Balmoral undergoing preparations for a new season with Red Funnel, *c.* 1935. She was their flagship until 1939. Built in 1900, with a 437-ton steel hull and with a promenade deck, she was capable of an amazing 19 or 20 knots. She was captained by A. Goldsmith from 1906 to 1938 and an inter-war excursion cost 12s 6d. Like *Lorna Doone*, the ship was worn out by wartime service. But Red Funnel Ferries has gone from strength to strength, celebrating its 135th birthday in 1996 and launching a new flagship *Red Eagle* in April of that year. (Red Funnel Ferries)

There was fierce competition between steamer companies during the early days. In 1899 this resulted in the London and South Western Railway's steamer *Stella* engaging in a race with the Great Western Railway's steamer; *Stella* was wrecked off the Isle of Wight as a result. Ferry traffic grew rapidly to around 100,000 passengers in 1830. Southampton's popularity as a spa resort accelerated demand and a proper pier became necessary. Queen Victoria and her daughter opened the Royal Victoria Pier on 8 July 1833. The original pier decayed rapidly, but was rebuilt and extended by the Harbour Board engineer, architect Edward Cooper Poole, and it reopened with room for ten steamers in June 1892. By the 1890s it could handle over 10,000 arrivals and departures yearly, and it cost Edwardians 1*d* to walk out on it. A railway linking it to town was added in 1914. This picture shows the pier in its twilight years, with the *Bournemouth Queen* at her moorings in about 1947. (Red Funnel Ferries)

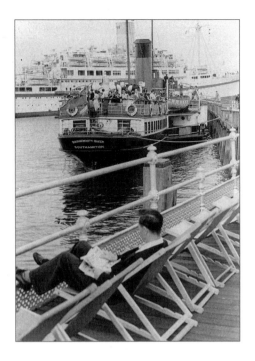

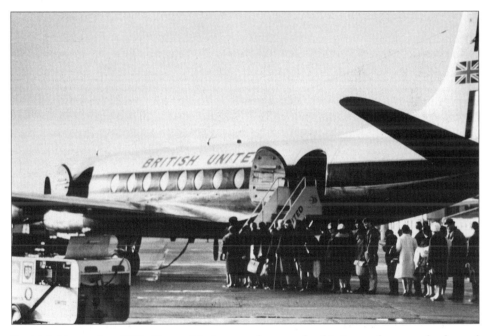

Eastleigh Airport, late 1965. Air travel had come a long way by this time and was much advanced by wartime developments in military aircraft. Small airlines proliferated. Imperial Airways metamorphosed into British European Airways and British Overseas Airways, which shifted their operation inland to London Heathrow. Smaller companies operated from Eastleigh, and the package holiday was all set to rival ferry excursions and holidays at home. (City Archive)

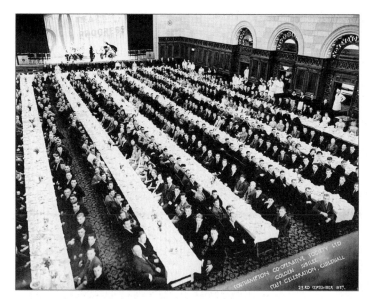

Southampton Cooperative Society golden jubilee celebrations at the Guildhall, 23 September 1937. The Cooperative Society was started by working people who each paid a share toward buying goods at bulk discount prices, thus avoiding the profiteers and the food adulteration so commonly experienced by working-class people during the nineteenth century. (City Archive)

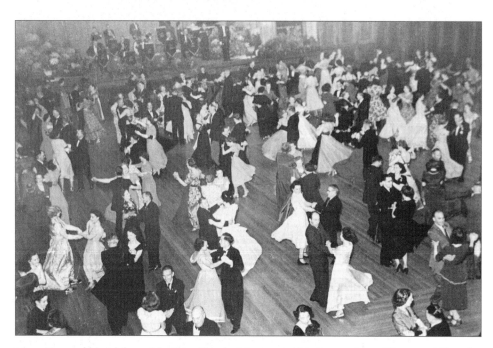

More Coop golden jubilee celebrations. The meal is over and it's time to dance. There would be a lot more dancing during the war years ahead. Gladys Eacher recalls meeting her husband Ken at a wartime 'social': 'I can't say we suffered a lot during the war. I met some interesting people. My mother was a firewoman and Ken was in the Civil Defence and Home Guard. We met at a fire brigade dance.' Ken recalls guarding vital communication links: 'We had a decoy railway junction at North Baddesley. They hit Southampton telephone exchange so it had to be bypassed. A bomb fell on the AGWI oil refinery at Fawley but no one noticed because the crude oil muffled the explosion and there was no oxygen for a fire. A lot of German airmen are buried in Fawley churchyard.' (City Archive)

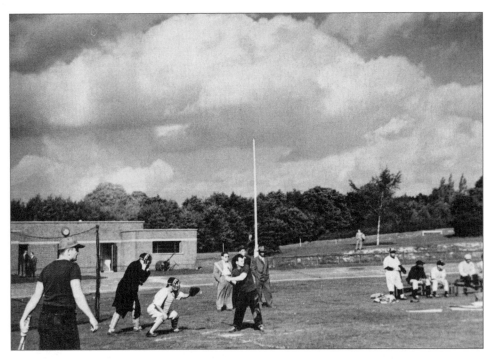

US Navy personnel playing baseball at Southampton in the summer of 1951. Visiting US servicemen were once a common sight, but they have vanished since the end of the Cold War. (City Archive)

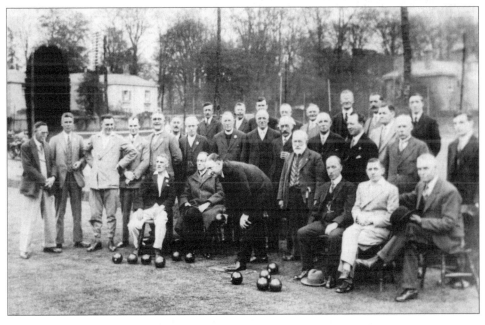

A gentle game of bowls at Bitterne Bowling Club during the 1930s. (City Archive)

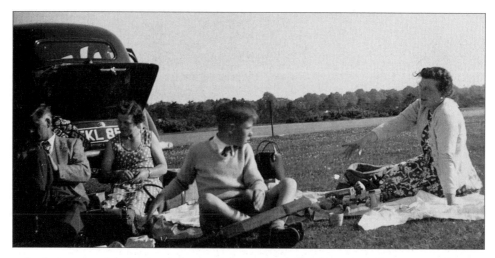

A family picnic in the New Forest in the summer of 1961. Car production accelerated along with road building after the Second World War, so that the Little family shown here could travel all the way from Havant with relative ease. The Forest was an ancient hunting ground but nowadays there is a constant battle to maintain the delicate balance of nature against the intrusions of mankind. There are rich pickings for developers. In April 1996 a Department of the Environment Circular proposed that councils can only negotiate with developers for affordable housing on sites for fifty or more dwellings, or for estates occupying more than 50 hectares — thus penalizing the kind of small-scale developments that councils can afford. (R. Little)

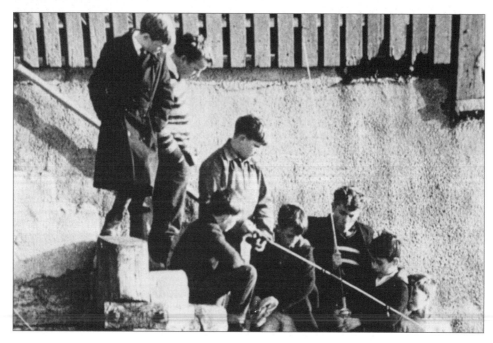

Living is easy for these 1950s schoolboys, engaged in the ever-popular sport of angling, hoping for a 'whopper' near the Royal Pier. (City Archive)

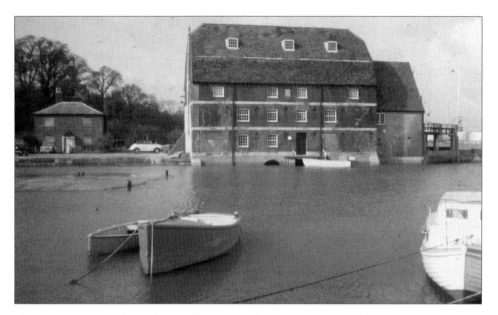

The Esso Refinery Club at Ashlett Mill in 1966. This was formerly a tidal mill and was a perfect setting for new kinds of leisure pursuits. (K. Eacher)

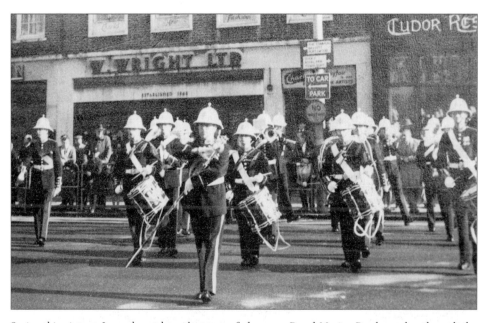

Seeing this picture, I can almost hear the tunes of glory as a Royal Marine Band marches through the town centre during the late 1950s. Southampton has a heroic past and here it is rightly celebrated. Royal Marines were nicknamed 'Bootnecks' because they used to wear leather collars. In the navy they used to say marines were neither soldiers nor sailors, and on board ship they were billeted amidships between the officers and ratings. Their tasks were to quell any mutiny and make up landing parties. (City Archive)

Students at Southampton's Highfield campus having a good old bash in 1988. I thought they were all supposed to be down in the dumps, suffering from the miseries of student loans! (F. Tanno/ *Wessex News*)

Some of Southampton University's rugby team, Easter 1995, sporting the dubious notion of 'Southern Superiority'. They are waiting for the ferry to take them to the Isle of Man. According to reports, the final day of their tour 'saw a last triumphant surge by Wessex Rugby. Boozing was at its best with only hooch, 'Neway' Brown and Guinness with port allowed to be drunk.' (*Wessex News*, May 1996). The University is a bastion of sexual equality and the same paper reported: 'Confronted with 18 teams of butch ugly-looking women, Southampton Ladies Rugby, with help from Southampton Institute Rugby girls, put up a great show of playing rugby, drinking beer and teaching everyone rugby songs.' (*Wessex News*)

William Berry was the fourth of ten chief constables who held office during the several lifetimes of Southampton Borough (1836–94), County Borough (1894–1964) and City Police Force (1964–7). The only one to die in office, he is chiefly remembered for starting the police band. His memo of 22 March 1895 said: 'It is proposed to organize a Police Band in connection with our force. The Mayor, Sheriff and Chairman of the Watch Committee have expressed themselves favourably as to its formation. I shall be pleased therefore to receive names of any members of the force who would like to have instructions in instrumental music. Of course this band will be considered as a matter of recreation and improvement amongst the men. Names should be sent as early as possible.' This picture shows the band still in tune during the 1962 annual Church Parade which was held at St Mary's Church. The bandmaster was the late Sergeant Stan Roper. (Hampshire Constabulary)

The *Southern Echo* launched an appeal for funds to start the Police Band and Roman Catholic priest Canon Scannell of St Joseph's Church in Bugle Street was one of the first to respond by sending a gold sovereign. This picture shows the band well established and performing at the 'Empire' in about 1930. (Hampshire Constabulary)

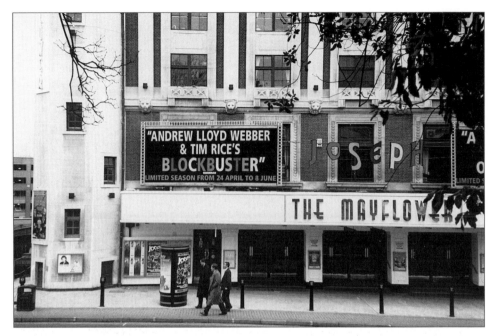

The Empire, a combined theatre and cinema, opened on Commercial Road in 1928 and is a survivor of a troubled industry. The rival 800-seat Grand Theatre near Above Bar opened in 1898 and despite various name changes had to close in 1959 because it could not compete with cinema. The Empire hedged its bets, offering both film and stage attractions. It was called The Gaumont when I visited in the summer of 1974, fresh out of university and looking for the 'real world'. Those were unisex days, before the media and economic system emphasized sexual rivalries. My long-haired girlfriend and I wore regulation blue jeans and cheesecloth shirts, and strangers would have had trouble telling us apart. We looked like the Barbie Sisters strolling into The Gaumont to see the anti-Vietnam War musical 'Hair'. The war was still on and protesting against it became part of student culture, doing much to create the 'hippy' sub-culture. 'Hair' by Gerome Ragni and James Rado expressed new ideas and freedom and had been revamped for the Southampton production. It was so easy for young lovers to sit there entranced, imagining a perfect future where peace lovers and beautiful people would come out on top and save nature. The rest is history. I had to get a depressing job, which meant a haircut. And that's when I found the 'real world'. The Vietnam War ended, the hippies vanished, apart from a few absurd hangers-on, and other wars started. 'Hair' had other idealistic messages, notably about pollution and trying to promote a happier lifestyle. Where has all that idealism gone? Southampton University's student newspaper *Wessex News* editor Liz Baker told me: 'Today's students are more pragmatic. They can't afford the time on all that 1970s stuff. We have to get jobs. We have to work much harder.' Money is the bottom line. Luckily the Gaumont has a new identity as the more exotic sounding Mayflower. It's a name suggestive of hope, reminding us of the people who sailed from West Quay, Southampton, in 1620 to start a new life. The city has some fine memorials to them in the park and Western Esplanade. But those early inhabitants of the New World were not so tolerant of anyone who opposed their views on life's basic truths. The musical 'Hair' was also a protest against America's conventional wisdom. New wisdoms come and go, all proclaiming they are truth. Thus women's groups espouse equality and then we read this in Southampton's student newspaper in November 1994: 'Proofs are finally being unearthed to support a truth which the more intelligent half of the population has always known. So why all the publicity? Well someone had to tell the men. . . . Yes it's official. Women are now recognized as the more intelligent sex.' It seems some part of humanity always wants to be superior and will fight to prove it! (R. Cook)

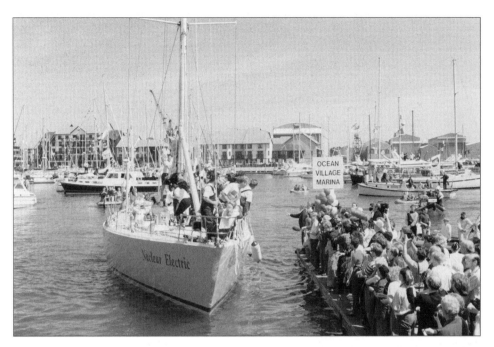

Southampton is a yachting paradise made famous by the 1980s television series 'Howards' Way'. Author Nevil Shute Norway humorously recalls the summer of 1919 spent on the Hamble River. Mr Hepherd, a local solicitor, needed two undergraduates to crew his 28-ton yacht. Shute recalls the nightmare of getting it down to Southampton Water via a river almost too narrow for it. The owner had a supply of visiting cards in the cockpit ready for the inevitable and numerous collisions. This picture shows the opening of Ocean Village Marina. (*Wessex News*)

Myself and son Kieran at Beaulieu National Motor Museum, located in the New Forest 14 miles south of the city, July 1988. Lord Montagu's museum was a novel idea to keep the stately home maintained. Thousands of visitors have been flocking there ever since the 1960s. Beaulieu Abbey was founded in 1204 by Cistercian monks, and what is now the Palace House was formerly their great Gatehouse. The Montagus have lived there since 1538 and the gardens are maintained in great splendour. Apart from this fine London Transport AEC RT bus, there is a large collection of motor vehicles tracing the story of motoring from 1895. (N. Cook)

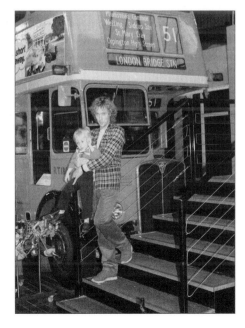

Boys will be girls and who can blame them? The clothes are so much more interesting! Also it's a way to get ahead! *Wessex News* reported in November 1994: 'Now that women have taken the lead you won't see them for dust.' This is Southampton University student Mark Williams dressed to thrill in January 1987. But he's not off to a job interview, this is for rag week – honestly! (M. Williams/ *Wessex News*)

In November 1994 *Wessex News* reported: 'Women are playing a greater role in the labour market, and 54 per cent of all new solicitors are female.' And here is another male student muscling in on the act, trying to look like one of the girls, 'dragging' one of those much sought-after hospital beds through the park in about 1990. Taking the equality battle a stage further in May 1996, Southampton bus driver Peter Benjamin asked his bosses if he could wear women's clothes to work. Peter said: 'The rights of men need to be stood up for. . . . Women wear trousers, why can't I wear a skirt.' City Bus considered EC equality regulations and a threatened strike by outraged colleagues, and then sacked him. (*Wessex News*)

Above: These are the dancing girls from Southampton University's 1987 Nuffield Theatre production of 'Bugsy Malone'. (*Wessex News*)

Right: A fashion show at the Post House Hotel, *c.* 1987. The model seems to be enjoying herself but *Wessex News* commented on the plight of twelve-year-old model Rachel Kirby in May 1996: 'It is many girls' dream to be plucked from obscurity and obviously Rachel Kirby was no exception. She described her first assignment as "Brilliant" and said she would "love to have all those people looking at me on the International catwalk". But surely this childlike innocence is open to much manipulation by many less scrupulous characters within the industry . . . the idea of trying to sell clothes to grown women, especially designer clothes at high prices, on pre-pubescent girls seems a nonsense to everyone.' (*Wessex News*)

Hockey nets look a bit like bus shelters and these five might be ready to fight their way on to an overdue and overcrowded city bus. But actually it's only a game, at Highfield Campus in about 1989. (*Wessex News*)

Section Five

Going Places

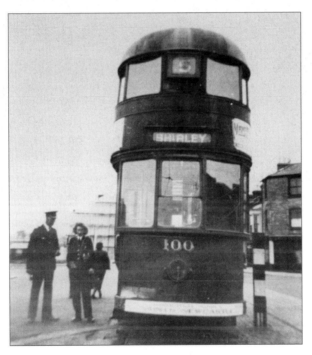

A tram bound for Shirley waits at Itchen floating bridge, c. 1930. In 1900 Shirley had been a place of tranquil ponds, complete with water mill and wildlife, but the expanding tramway brought it closer to the borough centre.

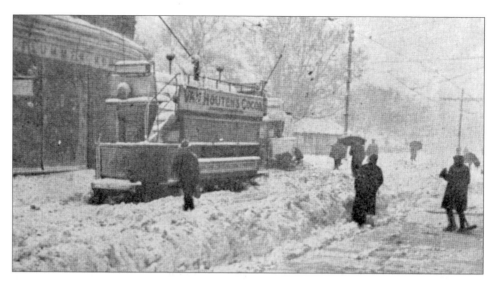

This picture was taken at the junction, Prospect Place, following a heavy snowfall during the early hours of 25 April 1908. Tram lines were buried and the town was brought to a standstill. The photographer was W. Bassett Lowke, a Northampton-based miniature model maker. Business brought him to Southampton to make large-scale replicas of vessels for shipping companies.

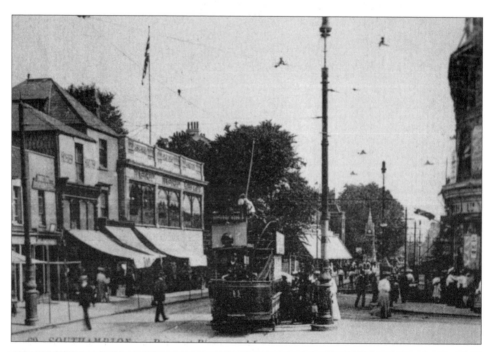

Prospect Place, 1908. The Plummer Roddis drapery, Above Bar, draws the crowds to its summer sale (far right) while across the road Dunsfords drapers are flying the flag. Passengers are boarding an open-top tram for Bitterne Park. Interestingly this type of tram, low enough to go through the Bargate, survived until the tramways closed on 6 June 1949.

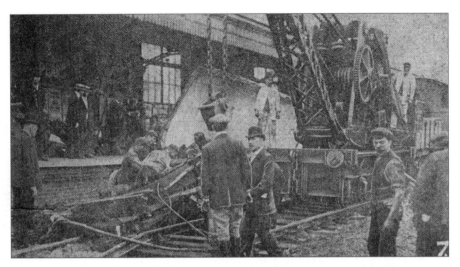

Development of the Southern Railway was crucial to Southampton's prosperity as a port and hence the boat train had special significance. Sadly this one, travelling at midday on 2 July 1906, did not make it past Salisbury station. This picture shows a crane raising the wreckage of No. 2 coach.

Crowds reading the bulletin listing the many passengers seriously injured; the list was posted at the gate of the infirmary.

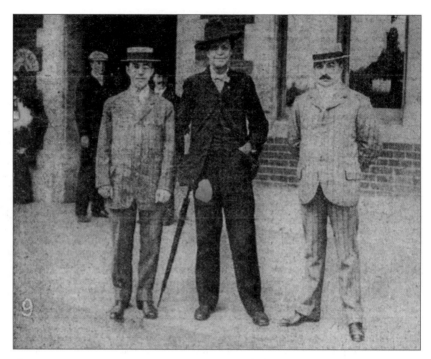

The American Consul at Southampton (centre) who arranged to have the bodies of American victims embalmed and sent to America. Surgeon H.G. Hinrichs is on his right, and Purser R.H. Urquhart of the Mail Steamer *New York* is on his left. The purser was called in to identify bodies.

The name Thornycroft is more often associated with ships but they also manufactured other types of transport, such as this new bus pulling up outside the park in 1930. Thornycroft employed many local people, converting ships into troop transports following the outbreak of war in 1939.

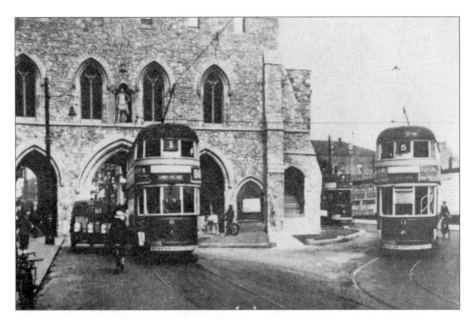

Eastgate had been demolished in 1775 for traffic reasons and incredibly Bargate was under threat in the late 1920s. By the time of this early 1930s picture, the decision had been made to demolish surrounding property (*see* page 8) so that traffic could get around it – though the tram cars designed in 1923 with low-domed roofs, of which fifty were built, could actually pass through Bargate. York Gate was demolished in 1961 but its name is preserved in the Bargate shopping centre, which includes the rebuilt frontage of a Georgian house taken from York Buildings.

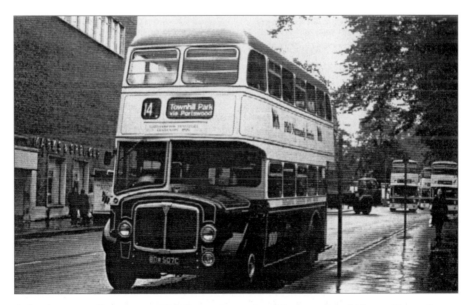

A Southampton Corporation AEC Regent bus painted in the original blue, white and grey, celebrating a century of municipal transport in 1979. (Ian Allan Ltd)

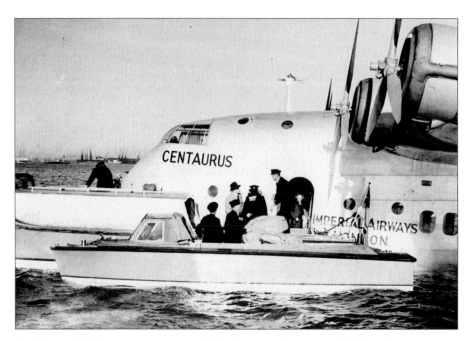

The Royal Mail Company was set up in Southampton during the 1850s and services were enhanced by flying boats like the one pictured here on Southampton Water in about 1936. Britain had a vast empire to maintain and landing large planes on water seemed the ideal solution. Flying boats were also considered safer if they had to ditch over sea. Their hulls could, however, be badly damaged by collision with driftwood. Ken Eacher remembers: 'I've been out fishing when flying boats came in. There used to be a motor launch with little boats and lights strung out behind. That was the flare path for night landings. When we saw it we knew there was a plane coming in from Australia or India. They were maintained at Hythe where Imperial Airways had a factory opposite the docks.' (British Power Boat Company)

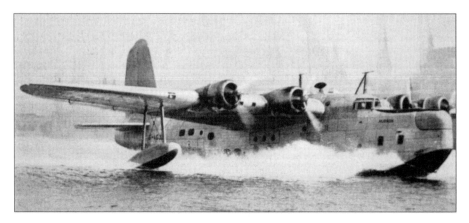

An RMA (Royal Mail Aircraft) Hudson ploughs up Southampton Water on its way to Madeira in the mid-1930s. The plane is a version of the Short Sunderland, stalwart of wartime RAF Coastal Command and the replacement for their biplane flying boats such as Mitchell's Supermarine Southampton. (Aquila Airways)

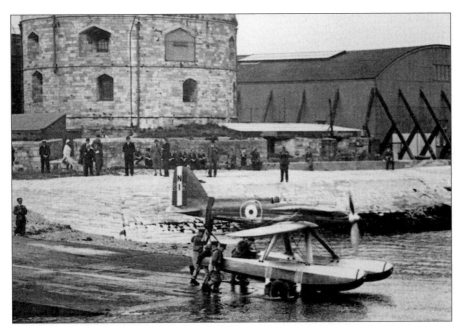

With the rivers Test, Itchen and Hamble draining into it, it is no surprise that Southampton Water has a long history of boat building, with considerable resources of skilled labour able to to turn their hands to the rising seaplane and flying boat industry. Reginald Joseph Mitchell (1895–1937) was an incredible asset to this local industry. He designed the Supermarine seaplanes pictured here, which were forerunners of the Spitfire. This one, being tested at Calshot Castle, entered the 1927 Schneider Trophy race and was flown into second place by Flt Lt O.E. Worsley. His RAF colleague Flt Lt N. Webster won with an average speed of 281.65 mph. (via V. Church)

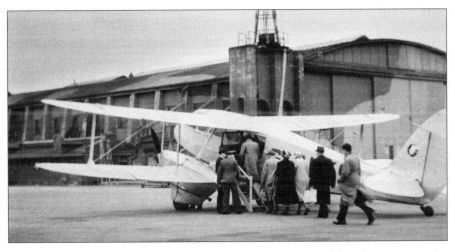

Eastleigh Airfield in the 1930s. These brave passengers are bound for the continent. The concept of airliners taking off from inland airfields was stimulated by wartime developments in long-range bombers. The flying boat's days were numbered – as were peaceful nights around Heathrow! (City Archive)

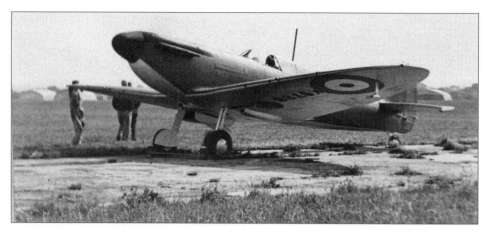

A Spitfire Mk 1 at Eastleigh airfield, where the prototype was test flown in March 1936 and the pilot uttered the legendary words 'Don't touch anything' after he had brought it safely back. Some took this to mean that the plane was simply perfect. No. 19 Squadron at Duxford had the privilege of receiving the first supply for service in 1938. (City Archive)

Duxford received a very sophisticated plane for the times and pilots found it rather a jump from the old open-cockpit biplane trainers. Spitfires went through many modifications during the years of wartime production. By the time the Mk VI entered service at Tangmere in April 1942, it was capable of high-altitude interception, using the more powerful Merlin 47 engine and a four-bladed propeller. A pressurized cabin avoided the need for pilots to wear a close-fitting oxygen mask. This picture shows one of the later types displayed outside the De Vere Grand Harbour Hotel during the plane's sixtieth anniversary celebrations in February 1996. (R. Cook)

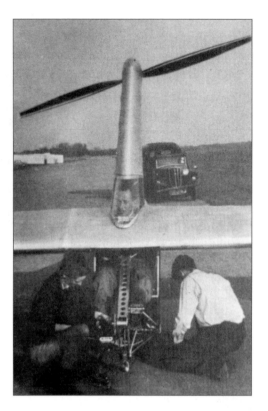

Southampton has been a pioneering settlement in many ways. H.R. Hartley left his High Street premises and wealth to the Corporation, who used it to found the Hartley Institution, which expanded to become the University College in 1902 and moved to Highbury where its buildings became a military hospital in 1914. The college became a university in 1952 and has a good reputation for research. Here is one of its more novel activities on 9 November 1961. The first British man-powered aircraft is getting ready for test flying at Lasham. Anne Marsden (left), one of the designers, is adjusting a pedal linkage. The plane was built to compete for the £5,000 Kremer prize for man-powered flight.

Pilot Derek Piggot, Chief Instructor of Surrey Gliding Club, had to produce 0.45 hp, roughly equal to cycling at 10 mph up a 1 in 10 gradient, to get airborne. The plane was mainly balsa and doped tissue, and weighed less than 130 lb empty. But it still took so much effort to keep it flying at 20 mph for 1½ miles, it was nearly impossible to find enough energy to steer it.

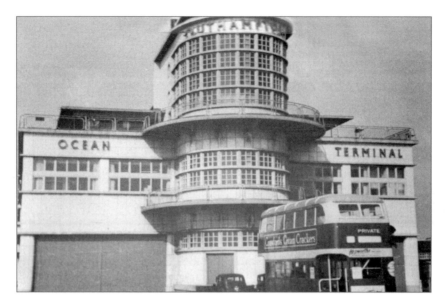

In the first three years after railway nationalization, 253 route miles of railway were closed and another 314 closed to passengers. The Labour government hoped to integrate different types of transport, hence Southampton's Ocean Terminal pictured here shortly after its opening on 1 July 1950. Joyce Adams remembers: 'I used to love going there and watching liners coming and going.' The building catered for passengers embarking and disembarking from the world's largest ocean liners. Waiting halls and customs were on the upper floor while below were platforms for trains, with all necessary facilities.

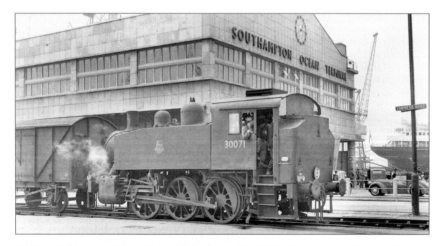

British shipping was still suffering during the early 1950s. Post-war taxation on shipping companies made no allowance for the increased cost of ships. Suez Canal restrictions and dock labour problems were also slowing down the turnaround of ships. Railways were struggling to recover from strategic bombing, in a world that increasingly favoured the apparent freedom and vested interests of the motor car. This good old American tank engine is doing its best to fight the tide, helping out with traffic at Ocean Terminal on 30 June 1953. The aft end of the *Queen Elizabeth* is just visible on the right. (B.K.B. Green)

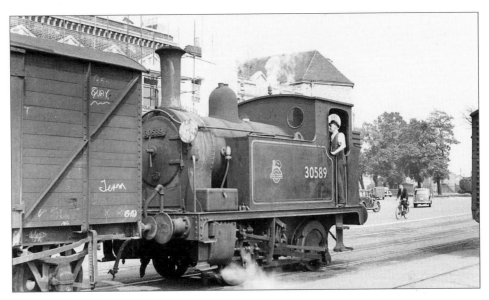

The Town Quay replaced West Quay as the town grew during the seventeenth and eighteenth centuries. More warehouses were built during the nineteenth century with goods being hauled by wagon. A horse tramway built in 1847 became a railway line in the 1870s but closed in 1970. The special light engine shown in this picture was a Class C14, number 30589, specially built for the new Western Docks and photographed on 30 June 1953. (B.K.B. Green)

This is the more powerful B4 engine, number 30082, taking a rest in a dockyard siding, also on 30 June 1953. (B.K.B. Green)

The B4s were displaced by the even more powerful USA types originally imported from the United States under the Lend Lease agreement to help the war effort. Four hundred were built by three American firms (Davenport, Porter, and Vulcan Ironworks) between 1942 and 1944 especially for the European war theatre. The first arrived in July 1942. The Southern Railway took over fourteen in December 1946 and kept one for spares. This is number 300065, photographed on 30 June 1953. The old Southwestern House makes an excellent backdrop to this picture. The BBC used this building until their new one was opened opposite the Civic Centre, and Bertram Adams fondly remembers making regular broadcasts from the crime desk there. (B.K.B. Green)

These two USA type tank engines were still going strong eleven years later when Colin Stacey took this photograph on 6 December 1964, although by this time they were being displaced by diesels. Not surprisingly, these engines were wider and taller than British-built engines and had a warning notice reminding loco men that 'When standing on the footstep you are not within the loading gauge.'

Relegated to dockyard duties from more dignified work on the London, Brighton and South Coast Railway, this E2 0–6–0 tank engine, number 32109, proudly displays the British Railways lion emblem on its side tanks. It was photographed in the docks on 17 September 1961. (B.K.B. Green)

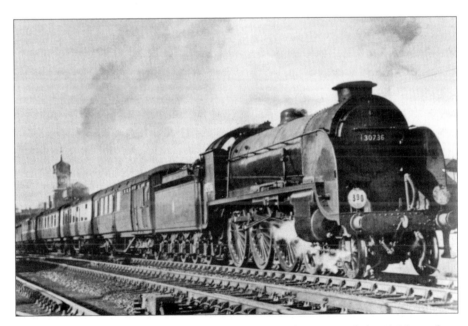

This is a 4–6–0 loco, number 30736 *Excalibur*, leaving Southampton with the 11.16 a.m. from Bournemouth West to York. The old ornate station clock tower is visible on the left. The tower was part of the red-brick station which replaced West End station in 1858. The station was updated and renamed Southampton Central in 1934–5. The clock tower was demolished when the station was rebuilt in the mid-1960s.

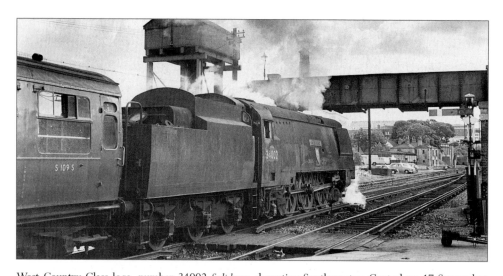

West Country Class loco, number 34002 *Salisbury*, departing Southampton Central on 17 September 1961. This magnificent engine was built at Eastleigh, north-east of Southampton and nowadays a part of the general urban sprawl, separated only by the M27 motorway. Eastleigh was mentioned in the Domesday Book but was fairly dormant for 700 years. But it all changed when the London and South Western Railway decided to move there in 1890 because they did not have room to expand at Nine Elms. The carriage works employed 1,500 men and the locomotive works 1,100. This meant that new housing was needed, and it resulted in the inevitable crop of three-up, three-down terraces stretching out along the Southampton Road. People travelled some distance for a job in the works. Joyce Adams remembers her dad putting her name down for a job in the administration section when she left Winchester High School: 'I was always good at maths but I couldn't matriculate because I did not pass French. Dad had a good clerical job at Eastleigh railway works. When my name came up I got a position in the estimating department using a comptometer. It was like a manual computer. I went on a course at Honeywell Comptometer School. You learned how to use it by pressing various buttons for hundreds, tens and units, etc. We had to check the mileage travelled by all the wagons to make sure proper maintenance was done. There was an old maid sitting behind a half-walled section looking over us all day. There was no central heating and the coal fire was up her end of the room, but you could go up and stand by it if you were cold. No one minded superiors because they were superior. It gave us an aim to get where they were. We had a smashing time. There were lots of dances and village hops. We made our long dance dresses out of curtain material and walked miles to the dance. I even cycled to work and back in the blackout and the air raids. I had no lights. What could you do if the sirens went? You kept pedalling. At least there was no danger of being molested. At work you had your gas masks under your desks and there was an underground room in case of air raids. We'd go down and sit on benches maybe for minutes or hours.' Ken Eacher was apprenticed at Eastleigh works, starting on 4s 6d for a 47 hour week, and remembers leaving home at 6.30 a.m. and returning at 5.50 p.m. He said: 'It was a hell hole, certainly not safety conscious. There was a lot of noise from primitive tools bashing metal and no ear protection. But we built good railway engines. Foremen wore bowlers and morning dress. We called them Sir. Their offices were perched high on the wall so that they could see all. There were no partitions in the toilets and we washed in a bucket of water made hot by 'rivet boys' heating lumps of metal and dropping them in it. We kept a respectful distance from the famous Mr Bulleid. He would come down on a special train from Waterloo. He looked very German, thick-set and bald. He had some interesting ideas for locomotives but post-war economics finished him and them off.' Latterly Eastleigh works has also fallen victim to economics, which has taken us back to privatization. The South Hampshire Rail commuter group criticized South West Trains recently for running a 'disjointed, cost-cutting service'. The company replied: 'SWT has to provide a minimum service under the passenger service requirement laid down by the rail regulator.' (B.K.B. Green)

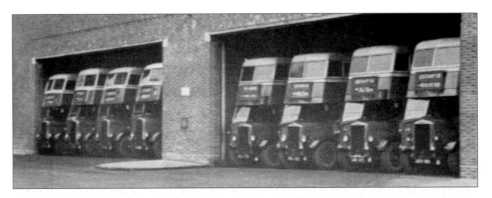

The new bus depot at Grosvenor Square in 1945. Since then the local bus scene has experienced many changes, including a period of operations under bus legend Ann Gloag, nursing sister turned public transport magnate. Her Stagecoach Company ran ex-London Transport Routemaster buses during the mid-1980s but sold out to Southern Vectis, which already owned Solent Blue Line. Stagecoach bloomed with the national bus sell-off and de-regulation. Now the company is taking advantage of the national railway sell-off, taking over South West Trains and looking for further opportunities as they occur.

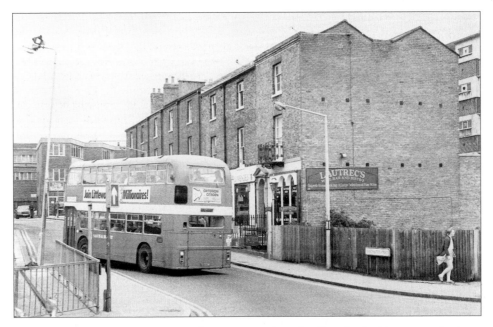

A Hants and Dorset bus passes along Manchester Street in the early 1980s. Good public transport has been a vital link for the city's more remote outposts, and catering for those who cannot afford or do not want to use cars. University students complain that services do not run late enough. No doubt that is due to the increasing use of private cars and the danger to one-man bus operators in an increasingly violent city. This bus advertises a quick way to become a millionaire but real profit comes from respecting the planet, not greed. City Council Leader John Arnold and deputy Alan Lloyd signed a petition for a Road Traffic Reduction Bill, following a leaked DoE report that one-third of Britain's major roads are expected to become grid-locked within a decade. (*Wessex News*/Martin Siese)

Southampton Transit production line 1985. In 2009 demand for vans has fallen through recession. Southampton docks are Britain's largest importer and exporter of new vehicles, handling 200,000 in 1987. (Ford Motor Company)

Motor cars have hastened the decline of railways and much else, including good manners. Hampshire has been branded a drink-drive black-spot, with convictions rising by 700 in 1995. In 1996 road rager Nigel Hunt, aged twenty-eight, sprayed de-icer in the face of Eastleigh driver Maxwell Thirkettle and his fourteen-year-old daughter. Maybe this sick behaviour has something to do with the egotistical effect of cars, leading to a 'me-first' mentality on very congested roads. Here is the usual run of afternoon traffic detracting from the fine lines of the Civic Centre in March 1994. (R. Cook)

SECTION SIX

THE WAY AHEAD

*This cast-iron County Council signpost at Blackfield is
left over from the past. Do we need to look back to find
a way forward? (R. Cook)*

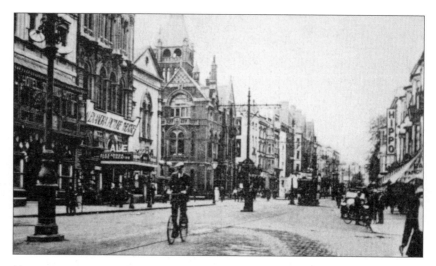

Above Bar, *c.* 1914. Far left is Scullard's Hotel which was demolished to accommodate the Regal Cinema, which became 'The Odeon' in 1945. Scullard moved along the road to the White Hart which was rebuilt after the blitz but closed in 1973. The Alexandra Picture Theatre next door opened in the old Philharmonic Hall in 1912 to show the borough's first movies. The cyclist in the foreground needed to be careful to avoid catching his wheels in the tram lines. Joyce Adams said: 'You had to flick your bike quick or you'd be caught, then you'd hear the old tram bells ringing.' The church just off centre was the Church of Christ, built in 1881 and rebuilt as Above Bar Church in 1979. The Hippodrome (originally the Prince of Wales) opened in 1883 and is advertised on the right of the picture. Lillie Langtry appeared there.

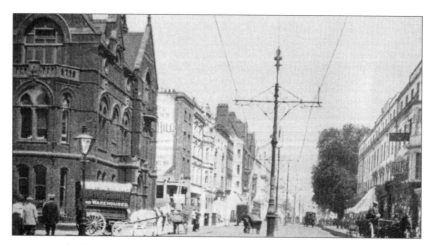

The Victorian Gothic building on the left of this 1890s scene was the Royal Southampton Yacht Club, on the corner of Ogle Road. The classic column gas lamp was fuelled by the Southampton Gas Company (later Southern Gas). Gas was advertised as 'cheap and speedy' energy for industry and home. The company said: 'Southampton holds unique opportunities for industrial development and gas is the one fuel to ensure success in factory or works.'

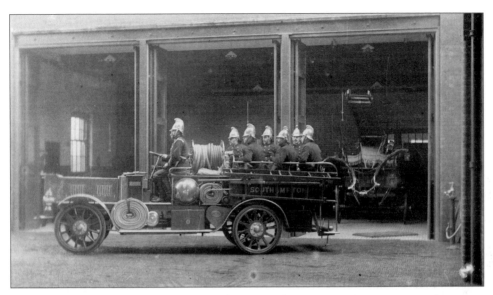

Southampton's first motor fire engine, an Aster Merryweather registration CR654, photographed on delivery in around 1909. The old 60 ft horse-drawn escape ladder that it replaced is visible in the background. The large cylinder under the driver's seat was a soda acid extinguisher, which made carbon dioxide when mixed with water. It carried 50 gallons of water and dealt with disasters like Hart & Co.'s furniture shop fire in Bridge Street in January 1912 – where the damage was estimated at £25,000 and extra constables had to be posted to prevent looting. Assistant Chief Fire Officer Alan House recently published a brigade history called *Gateway Firemen*. He says that Southampton's three stations deal with around four thousand incidents a year, and that modern buildings are actually less resistant to fire than most older ones. (Alan House)

St Mary's fire station photographed on 10 October 1972, shortly before demolition. The building was opened on 27 March 1909 as headquarters and main station. (Alan House)

The new Itchen bridge rising majestically above the river in the late 1970s. The bus crossing it looks as lonely as the man poking about in the mud.

The Roman Baths complex in Commercial Road in the late 1980s. It all looks a far cry from the glory that was Rome, and her empire which extended to include a settlement at Bitterne. Empires and ideologies come and go but basic needs have always to be met. Invoking the names of more glorious times may add a little glamour to these basics. (*Wessex News*)

J.H. Bigland's bakery, 120 St Mary Street, looking very traditional and appetizing. It's nice to see such a tasty old corner shop which is still in business. Sadly a hardworking Asian shopkeeper took his own family's life: racism seemed to be part of the reason, but there was also the problem of competition from an increasing number of superstores in the Southampton area. (*Wessex News*)

Late 1980s university students participating in a 'Blind Date' routine at a Valentine party. Inspired by Cilla Black's much maligned television series, the idea of a blind date market-place has been criticized for encouraging contestants to act out stereotypes and indulge in innuendo. But maybe the critics have led sheltered lives and these people are only doing what comes naturally. Discuss! (*Wessex News*)

Will they ever learn? This is not what feminists and New Labour want of 'millennium man'. Who says dinosaurs are dead? What will become of this fellow? Stockbroking, perhaps. This was after all the 1980s when 'work hard, play hard and get a Porsche' were the messages coming from the Thatcherites and amplified by the Stock Exchange 'big bang' – but we all know that big bangs can so easily end in tears. (*Wessex News*)

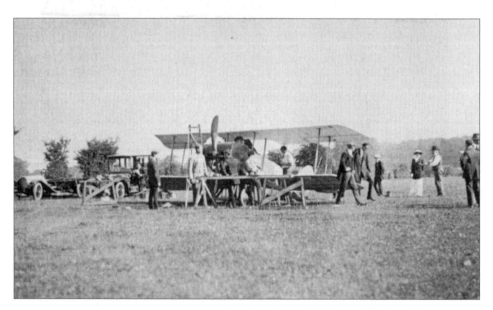

There are other ways of getting high, like flying. But during the period shown here it was more risky than the alcoholic activities shown above. This is the Supermarine Works at Woolston which was started by Noel Pemberton Billing in 1913. The plane is a PB9 ready for testing at Netley. Considered a fast plane at the time, it would be hard pressed to reach today's motorway speed limit.

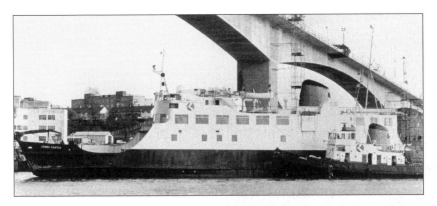

Red Funnel's *Cowes Castle* passes under the new Itchen Bridge, still under construction. The ferry would only have been this far up the Itchen to visit a repair yard. Red Funnel gave much pleasure in a bygone age. Gladys Eacher recounts from the 1930s: 'When we were children we used to have a day out on the Isle of Wight during summer holidays. We were landlocked. It was marvellous to go to sea.' (Red Funnel Ferries)

Southern Television studios near Northam Bridge in the late 1970s. It is a moot point whether television helps or hinders public consciousness, with its appetite for salacious dramas and grisly or inane news stories delivered by suave, glamorous and 'above it all' reporters. Their very life blood is people's trials and tribulations – and there's no shortage of raw material around Southampton. As the old ways of talking and living disappear, the broadcasting élite act increasingly as judges of political correctness and arbiters of good taste. Elected politicians must learn to treat these image makers and breakers with care. (*Wessex News*)

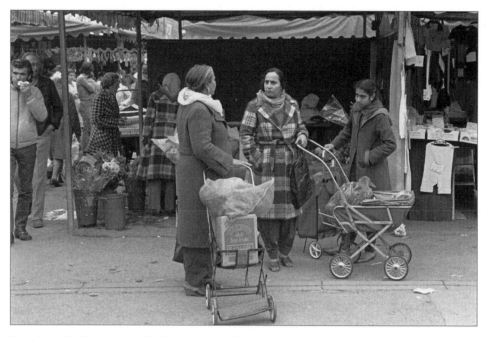

Kingsland Market, St Mary's district, in the late 1970s. This area had a reputation for social difficulties and residents campaigned to get prostitutes off the street and so drive kerb crawlers away (*see* page 25). Violence is still a serious problem. In February 1996 Alan Gill of Oslo Towers was jailed for twenty-one days for trying to throttle a Happy Shopper worker who tried to stop him shoplifting spaghetti. In July 1996 Judge Tucker, taking into account nineteen-year-old Ragbhir Singh Digwa's seventeen other offences, jailed the Shirley resident for life. Tory MP for Southampton Test, James Hill, said: 'Mugging has been a perennial problem in certain parts of this city.' Probationary Police Constable John Arlott once observed that pre-war Southampton was almost without evil, though he acknowledged that life below Bar was hectic when seamen were on the spree. His memoirs indicate he was a little bored by his job and looked forward to a more exciting life as a cricket commentator. If he were on the beat today there would be plenty to keep him interested. Events in 1996 included a young businessman, Roshan Bhatti, who was nearly blinded by CS gas when three racists attacked his car in Shirley. A pub fight outside McClusky's city centre bar cost PC Florrit a chipped tooth when he tried to stop a drunk wrecking a parked car and PC Ali Mears needed eight stitches after being beaten with a bar stool at the Dolphin Hotel, Botley. Problems start at an ever earlier age. Local schoolboy Andrew made headlines for being permanently excluded from school – aged only fifteen. The school detailed a catalogue of problems and said he was excluded for the good of the other children; now Andrew's mother says his education is ruined. She said: 'Schools are too worried about their image. You can't abandon kids at fifteen.' But older residents won't be abandoned either. Nearly six hundred people from Netley turned out to deal with teenage vandals, and sixty from Bitterne held a meeting with councillors to discuss problems. The *Daily Echo* asked whether we should just stand back and watch vandalism grow, and noted that people power is on the march. But there are no easy answers. Professor Michael Zander shocked guests at a Southampton talk in May 1996 by saying: 'Almost every word said and promise made to us by politicians about how to tackle crime is absolute nonsense and not likely to be achieved.' Elaborating, he noted that only 1 per cent of non-car crimes resulted in a conviction, and criminals were not just a part of society, but were woven into the fabric of every part of it. In a city the size of Southampton, on an average day, each beat policeman is responsible for 850 acres of parkland, 770 miles of road, 1,400 miles of pavement, 75,000 houses and 230 pubs – all at once! (*Wessex News*)

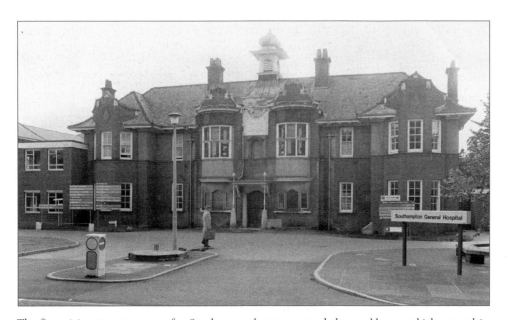

The first civic attempt to care for Southampton's poor created the workhouse which opened in 1776 and expanded in 1868. The first proper hospital followed the High Street fire of November 1837 when Dr John Buller rented a casualty ward at South Front. With his surgeon brother William he raised funds for a site at Newtown, which was opened in 1844 and extended to 275 beds by 1933. Meanwhile the Poor Law Guardians had bought 35 acres at Shirley Warren to build the hospital shown above. Built by local firm Cawte's, for £64,800, it provided 289 beds and became Southampton General following the establishment of the National Health Service. A military hospital was opened at Netley to cope with Crimean War casualties in 1856, a conflict which made famous health reformer and nurse Florence Nightingale. Maybe we've improved on Nightingale's efforts – but is it good enough? The poor chap in this 1980s picture looks rather wistfully at the intimidating façade. He is clutching his case and maybe going or coming. Anxiety is inevitable on these occasions, made worse by so much bad publicity. Patients might almost expect hotel standards, considering that Southampton Community Health Service spent over £74 million in 1994/95. But is that enough? On 9 May 1996 an extra £25 million was allocated to the Southampton area where the University Hospitals Trust is £11 million short of its needs. The Trust is axeing 373 jobs and has agreed with its main purchaser to rank its patients in order of priority. Nationally the number of hospitals decreased from 3,025 with 545,000 beds in the late 1950s to 1,960 hospitals and 309,000 beds in 1993 – now the population has increased significantly and it is ageing. Responsibility falls increasingly into the hands of junior nurses and medical accidents have risen to 30,000 per annum. In order to cope, Southampton has increased the number of outpatients. Research at Southampton General (May 1996) revealed high levels of malnutrition among patients living at home and suffering from chronic illnesses. Thousands of patients have been relegated down the hospital waiting lists and jobs have been axed in order to bridge the £11 million funding shortfall. Itchen MP John Denham (Labour) said: 'The health authority and the Trust are putting a sticking plaster over a deep wound.' Getting a hospital bed is a mixed blessing. Southampton nurses are campaigning to curb the growth of antibiotic-resistant superbugs known as MRSA. They estimate that one in ten patients will pick up an infection while in hospital. Consultant medical biologist Dr Ann Pallett said the growing pensioner population will be at particular risk. Beverley Webster, cardiac clinical services manager, believes the internal market has been a major factor in the spread of MRSA in hospitals. Trusts competing for patients are under pressure to treat as many as quickly as possible. There are even reports of parents planning legal action because dental operations took place without sterile instruments. (*Wessex News*)

The local hospitals may have changed but the ESSO headquarters at Fawley looks timeless in this 1994 winter view. The company was established in Britain in 1888 as the Anglo-Iranian Oil Company which now operates through ESSO UK plc, a holding company. It was the first foreign affiliate of John D. Rockerfeller's Standard Oil Trust. Work started on the present Fawley refinery in 1949, the same year as the first issue of ESSO *Employee News* – the American management believed in keeping in touch with the workers. The new refinery was built on land belonging to Cadland Manor, which had gardens laid out by 'Capability' Brown. The manor was bought by the American Scott Payne family. (R. Cook)

The *Queen Elizabeth* passing Fawley Marine Terminal in 1963. Fawley received its first crude oil delivery on 14 September 1951 and the Prime Minister, the Rt Hon. C.R. Atlee, performed the opening ceremony. Ken Eacher recalls: 'Fawley was a remarkable place. You approached through an avenue of trees and the starting whistle came off a Mississippi paddle-boat. It was a pleasant, uplifting sound. The conditions were much better than I'd had at Eastleigh loco works. There were doctors and nurses. The management was more friendly and integrated with the workforce. You respect them for that. They were typical Americans, calling you "Mister". The work was heavy but I was only there three years before becoming an inspection engineer. Sometimes I'd work all night in a tower full of tar-like material. But we could negotiate a decent wage. If we wanted another 4*d* an hour we'd ask for 6*d*. I worked at the original AGWI [Atlantic Gulf and West Indian] refinery and on construction of the new one in 1949.' (K. Eacher)

The dark-suited men, flanked by two commercial vehicle sales staff, are Martin Offer (left) and his father Norman Offer. In the foreground is young Norman. They represent three generations of a family firm which started with one vehicle in Norman's back garden near Romsey, in the days of A&B licences. The firm grew during the 1970s, carrying Fyffes bananas *et al*, and diversified into container work. (Martin Offer)

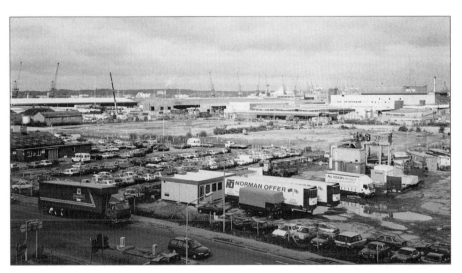

Offer's depot near Western Docks. On the skyline is the incinerator which has been the scene of several protests because of the cancer risks from burning city refuse. Offer's moved here in the 1970s, alongside British Road Services (BRS), and expanded quickly, moving into customs-approved warehousing. The small ERF lorry in the foreground is both hobby and promotional and once belonged to an Oxford man who delivered parcels for BRS in the 1950s. The man went on holiday, returning to find his contracts had been placed elsewhere. Promptly he went home, collected his shotgun, and came back and shot his depot manager. (R. Cook)

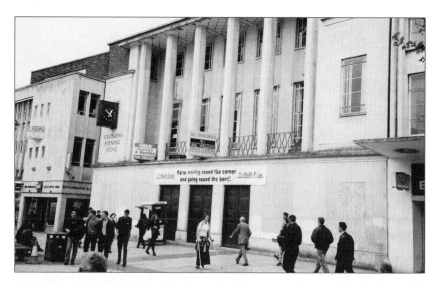

The deserted *Echo* building, 45 Above Bar, a site chosen by newspaper chairman Walter Perkins in 1906. He went out to the street, threw his walking stick into the air where it whirled around and landed pointing north to Above Bar. Subsequently the building was gutted during wartime raids which started in the late summer of 1940 and peaked in November when the town's commercial centre was destroyed by incendiary bombs. But the paper never missed an edition because pre-war plans for emergency moves to Bournemouth came into effect – though reporters remained in the thick of it. The post-war building shown here was opened on 21 November 1955 by Lord Louis Mountbatten and there were no drastic alterations until computers revolutionized newsprinting in the 1980s. (R. Cook)

There was no twirling walking cane behind the *Echo*'s decision to relocate here at Test Lane on the Nursling Industrial Estate, Redbridge. It was built with state-of-the-art technology in mind. The new presses first rolled in late summer 1996, providing greatly improved printing and high quality colour. The plan is to produce half the Southern Newspaper group's titles in this modern fortress of a facility. The old premises had become far too cluttered and could not cope with the pace of modern newspaper production. The *Echo* still has a front line outpost, with a new shop in Hanover Buildings for advertising and retail services. (R. Cook)

Rooms with a view: Redbridge Towers, Millbrook, March 1993. This was one way of rehousing the needy cheaply, and offered a good view of regular traffic jams, but it is hard to build vertical communities, and even harder to provide safe space for the children to play in and around them. But housing demand is high and what else can be done? (R. Cook)

The site of the old Pirelli premises in the city centre, which closed over a decade ago. Their Southampton factory made underwater cable and was an important employer. This area is now being redeveloped for more shopping; they used to say Britain was a nation of shopkeepers, now it seems to be a nation of superstore-keepers. STC's submarine factory in Western Docks was also planning closure at the time of writing. Since 1951 they produced specialized cable for laying on ocean beds for inter-continental phone and computer links, supplying half the world's needs. But satellite technology hastened their decline and French owners, Alcatel, have little option. (R. Cook)

New Forest ponies taking advantage of ancient grazing rights in about 1970. City expansion is a serious threat to this kind of habitat. The New Forest Committee has drawn on public opinion to draft a 'Strategy for the New Forest', laying out objectives for preserving the forest into the next century. (J. Ounsworth collection)

The ponies, which are taken to market by their owners each year, are still a landmark here in the New Forest in 1990. Verderers and animal protection groups claim the ponies are in better condition than they have been for years. Schoolgirl Donna Lailey is one of the new campaigners against cruelty to animals in the forest. She cites the case of an owner fined £3,857 for owning a pony that looked 'hunched, strained and distressed'. The RSPCA thus established the principle that it is the individual owner who is responsible for animal welfare, not the forest agisters. (V. Church)

A London Brick Company lorry delivering cheap Fletton bricks to one of the Southampton area's post-war new housing estates. These vehicles were restricted to 20 mph and it was a two-day job getting the lorries to and from Calvert in Buckinghamshire, where the bricks were made. Drivers would stay overnight at some of the curious transport cafés which provided drivers' lodgings. Bob Tyzack made many Southampton runs and remembers an old tanker driver who used to get straight into bed with his overalls still on, worried because he thought they didn't always change the sheets. Another wore a large overcoat in summer, until the day the reason became apparent – he dropped a pile of cutlery which he had stolen from underneath it! (J. Bromfield)

Mrs Sylvia Church and friends outside her new Blackfield home in 1979. This estate is on the edge of the New Forest, near Fawley – a much sought-after area as estate agents would say! But this creates conflict with nature as it is easy for humans to overwhelm nature. Every day the roads to Southampton are clogged with commuters, in spite of road improvements. The remains of the old bridge at Redbridge are a reminder of quieter times. (V. Church)

'Southampton is a womanly city', said one local. There certainly seem to be a lot of dress shops to prove this point as this 'olde worlde' part of the Marlin shopping centre shows. Stories like the young nanny who alleged but later withdrew a charge of rape against an Afro-Caribbean – an attack said to have taken place in broad daylight near the Dell football ground – paint a picture of women at risk in a violent city. In fact men are more at risk from city violence but this makes less of the headlines; perhaps it's taken as too mundane. (R. Cook)

Schoolgirls in Above Bar, May 1996. One might be asking, 'Which way shall we go?' They could face a bright future. Traditional male skills are less needed and traditional ideas of manliness are subject to media ridicule. Sarah Cordey told fellow university students (*Wessex News*, 14 November 1994) that the 'outlook has changed completely and female maturity is being identified with better communication skills because they talk to each other more than boys. . . . The economy has changed, meaning a far greater demand for communications and language skills where girls are far better qualified.' (R. Cook)

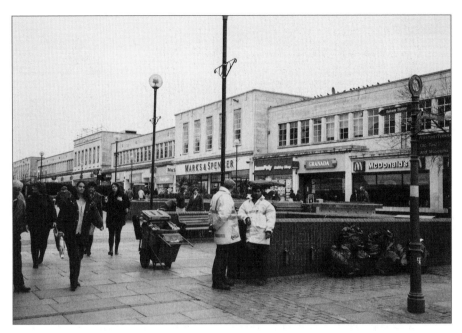

Strangely, the majority of the male workforce have always been in low-skilled work, such as vitally important street sweeping as shown here in Above Bar in the winter of 1995. However, the minority of top and professional jobs have long been monopolized by men, although that is now changing. (R. Cook)

Leafy Southampton has a population of over 200,000 and it is the largest municipal borough on the south coast. Ian Taylor, Whitehall's Minister for the South Coast was criticized for not knowing population details. He explained: 'Where I think I have already shown we can have influence is where a particular issue connected with Southampton is brought to my attention'. Well, here's one: a man on the scrap-heap, Ronnie Stone, near the entrance to ASDA's city centre supermarket. Born in Southampton, he says: 'It's not a bad place but you've got to watch where you "do skipper" [sleep rough]. I've had to lock myself in the public lavs at 3 a.m. in the morning. I get my down days, especially when it's raining. The library's good and I can get cleaned up at the day centre. I like to drink Tennants and Carlsberg mostly. A few people say hello. I have two sisters but I don't see them. I used to be a labourer. My wife went off with someone else. I found them in bed.' (R. Cook)

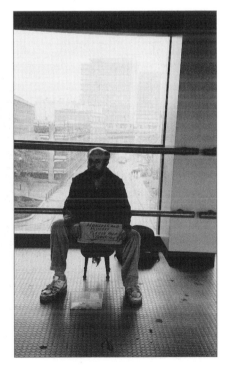

The original Above Bar Church survived the war only to be replaced by this redbrick building in 1979, which is hardly distinguishable from the neighbouring offices until the funeral cortège arrives and reminds us that all of us are mortal. Those were the days when gents raised their hats at such a sight, but now there are few hats to raise and suspicions might be aroused if one stops to stare (*see* page 109). (R. Cook)

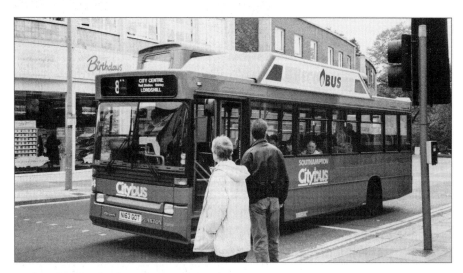

With gridlock approaching, few people are ready to face up to the evils of motor vehicles, but at least City Bus are doing something to clean up public transport with this type of bus, running on natural gas. But more cars are expected and new roads planned. Still the congestion worsens and it was all too much for local wheelclamper Steve Slack, who gave up the job along with his company car after less than three weeks with Southampton's controversial wheelclamping firm, International Security. Their bonus scheme offers £17.50 per clamp if the clamper immobilizes 140 vehicles a month. Steve said he wasn't the type to clamp a woman if she'd just forgotten to display her ticket at the railway station. (R. Cook)

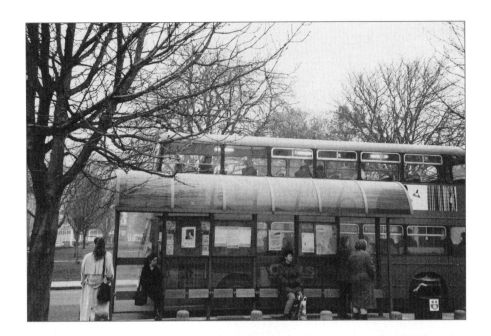

Above: Bus stop modernism outside the Civic Centre, February 1996.

Right: A man from another age, R.J. Mitchell, ostentatiously smoking, but then it wasn't known to be harmful. Mitchell was a pioneer and an individual. Much as he is applauded today, especially for designing the legendary Spitfire, it is doubtful whether his style would flourish in the modern corporate world of teamwork that we have today. People nowadays are perhaps more like the components in Mitchell's aeroplanes – interchangeable and dispensable if they become too stressed. But people are still inspired by Mitchell's legendary advancements and Marlands Museum is dedicated to them.

William Leeson joined the Southampton police in 1895 apparently aged 'only 50' but with nearly forty years' service in the 1st West Riding and 1st Lancashire Regiments. Well over 6 ft tall, with brown hair and grey eyes, he was an ideal figure to be the first Bandmaster and Hackney Carriage Inspector for the wage of £1 per week. He retired from the police in 1901, continuing as bandmaster until 1905. Records comment upon his great age, so maybe he'd been over fifty when he joined – ageism did not exist then to block his talent! (Hampshire Constabulary)

Sergeant Stan Roper, Bandmaster from 1959 to 1966, came from three generations of Portsmouth musicians. Stan became a boy musician with the Royal Marines, joining in January 1929 aged fifteen and serving on Her Majesty's Yacht *Victoria and Albert* (*see* page 45). He was a holder of the King George V Silver Jubilee Coronation Medal and chose to join Southampton Police rather than Portsmouth because they had a band. (Hampshire Constabulary)

Chief Superintendent Bertram Adams, who joined the Borough Police before the war and transferred to Hampshire Constabulary when nationwide amalgamations reduced the number of forces from 200 to 47. Bertram recalls: 'A lot of "City Men" didn't like the change. But it gave us more resources for major murder enquiries. I commanded a minesweeper during the war but was released early in 1946 to get back in the force. Southampton was a borough until it received city status in 1964. In those days it had near full employment. I wasn't long in uniform before going to CID and becoming Shipping Officer. I dealt with all crime on ships, including a few murders. I used to go by boat down river to meet the ships; it was no good waiting till they came in or the crew would disappear.' Perhaps the most fascinating case was the gold bullion theft from the 38,000-ton RMMV (Royal Mail Merchant Vessel) *Capetown Castle* in February 1965. When the news broke, Supt Adams told his men: 'We are going to search this ship as no ship has been searched before.' (B.A. Adams)

Gold is so dense that all 130,000 tonnes ever mined would fit into 23 cubic metres and could be carried inside four jumbo jets. It's incredible that so little metal — which has few practical uses — generates so much power in the world. It's not surprising that so much effort went toward stealing the twenty 28 lb bars pictured here. There were 240 passengers and 366 crew on board the *Capetown Castle* when she docked on a dismal morning in Southampton. Her mixed cargo included gold bullion worth £8,730,000 and consisting of 1,746 28 lb bars each worth £5,000. There were two bars to a box, stowed in No. 3 Hatch in the ship's strongroom (specie room). Opening and checking the room followed strict procedures and there was total disbelief when ten boxes were found to be missing. (Hampshire Constabulary)

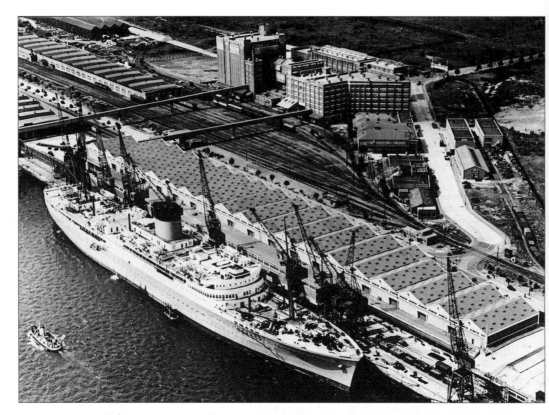

A Union Castle liner in Western Docks in the mid-1960s, presenting a similar scene to the one Detective Superintendent Bert Adams, Deputy Coordinator of no. 6 regional crime squad, visited in February 1965 in the search for the missing gold. Even the funnel was searched. The ship nosed into Southampton after a six-week round trip to South Africa. Bert noted: 'As the Cape mailships have always been, she was dead on time – 6 a.m.' When the specie room was cleared at 9.30 a.m. all seemed well. But extra gold had been stowed in the port stowage locker and five heavy metal bars had to be burned off the door to get it open. Inside, twenty bars had gone missing. Bert was informed but could hardly believe it. By the time enquiries commenced the passengers had left and the crew were paid off. The crime might have taken place 6,000 miles away. But police found a copy of the *Daily Mail* dated 17 January inside the locker, which had been 'sealed' on 14 January. Next they found sheet metal which appeared to have been cut from a ventilating shaft. Hatchmen Raymond Messer Williams and Neil Francis Hawthorne were soon suspected. The ship had been back and forth to South Africa before the gold was eventually found cemented to the deck of the cooling passage and painted over. The plan had been to sell the hoard to the Indian High Commission in Durban. Bert visited South Africa and the seamen gave in and confessed under fierce interrogation, each receiving ten years in prison. When Bert retired in 1973, the *Echo* commented: 'He is a very human sort of bloke . . . well thought of by all and sundry. . . . He has a tremendous sense of humour. He has the ability to make light of even the most difficult situations.' One such situation was a £10,000 wages snatch at Warner Hudnut's pharmaceuticals, Eastleigh, in June 1968. Information about the snatch was leaked to Bert via an informer. Expecting to face shotguns, three of the twenty-five police were armed. Detectives replaced the regular clerks in the wages car and faced a rain of pickaxe handles and ammonia sprays. Luckily, the one shotgunner was too startled to react to Bert's advancing army. Warning shots were fired by the police and one villain sustained a shoulder wound. But it was all in a day's work for Bert. His wife Joyce said: 'I never worried about him. I knew he could always cope.' (Associated British Ports)

I took this photograph in May 1996 while recuperating from a broken leg and hobbling about with a walking stick. I waited a moment to get the right balance of people for this Above Bar scene. Look carefully at the upstairs window – was I being watched? (R. Cook)

Maybe terrorism has increased people's awareness, for a few moments after taking the top picture it was a case of, 'Hello, hello, hello, what's all this then?' These two police officers had been called to investigate what I was doing taking pictures of The Woolwich. I pity the police, especially the woman if Dr Jennifer Brown's recent report is accurate. As head of Hampshire Constabulary's research and development, she says that half of the policewomen questioned in a national survey had been sexually harassed by colleagues. Even though many female officers disagreed, she has pursued her research and says sexism won't go away until women make up 20 per cent of the force. Women are being pressured into acting like 'the lads', but at least the locker-room pin-ups are coming down and women can go on courses to increase awareness of the problem. (R. Cook)

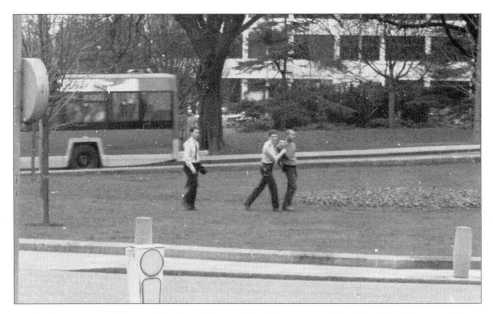

To me the greater problem is that the job is tough and tension needs to be reduced. Criminals are just not getting caught, but outside researchers perhaps allow ideals to obscure reality. I was standing outside Southampton Magistrates Court when this young man burst through the door and I thought, 'Here's another one glad to get off with just a pep talk.' Then his mate burst out after him, sprinted down the steps and across the carriageway, hotly pursued by policemen and women. It was a chase to warm the heart of the late local comic genius Benny Hill, although unlike Benny's controversial capers, the policewomen kept their skirts on! Here is one of the villains being manhandled – I hope in accordance with the 'be nice to nasties' directives in February 1996. (R. Cook)

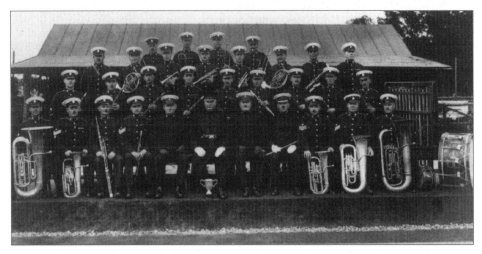

Since the days of the *Titanic* disaster, bands have been a comfort, playing on through difficulties and disasters. This picture shows Southampton County Borough Police Band after their winning performance in the police section of the London and Southern Counties Military Band Festival at Alexandra Palace, London, 8 September 1928. (Hampshire Constabulary)

The busker is a familiar sight in any large town or city and this one in Above Bar, last winter, made himself irresistible by training his dog to hold the cap. Comedian Arthur Askey once said on 'New Faces': 'Whenever I see a young man with a guitar, I always say, ay ay, they've opened another can of 'em!' (R. Cook)

Australian Linda Cahill at Novotel swimming pool, May 1996. She said: 'I last visited ten years ago. I've been in Southampton a week and it's boring. It's not friendly and there's nowhere good to go out eating [I'd dispute that – British Home Stores Restaurant is great.] They just don't cater for tourists. My husband's doing a ship-handling course and colleagues are asking him: "What on earth is your wife doing with herself?" Life has changed here. There's a lot of poverty around. I saw a guy outside ASDA with a sign saying "Homeless and hungry". People here are just sad.' (R. Cook)

Modern art next to the Nuffield Theatre at Southampton University in the 1960s. This Henry Moore-style comment on the age leaves me wondering. Is it putting two fingers up at good taste? I'm not a fan but I believe some people enjoy looking at it. I suppose the best thing about it is that it can be all things to all people! (*Wessex News*)

These figures are also making a statement, just as students always did – at least those reading sociology did – back in the 1970s. They make a rather quaint centrepiece to all the other rainy day images. With flares like that and the Thatcherite wind of change, such students would soon be blown away! (*Wessex News*)

William Waldegrave visited Southampton University students in the 1990s. University places have risen from 192,000 in 1961 to over 1.6 million today, and the students are a far cry from the hippy dreamers and romantics that I remember; now they dance to a tune written by a government keen to show that they are increasing opportunities for young people. But I notice on this occasion William's hands are empty. Perhaps he's demonstrating how government ministers can make good conjurors. Maybe he learned it from Lord Keith Joseph, father of Thatcherism. Visiting Southampton University in 1992, Lord Joseph denied that Mrs Thatcher became a Frankenstein's monster, saying she just 'made mistakes'. Self-motivation had always been her message – something a recent report suggested students lacked! (*Wessex News*)

Union Cloakroom

What's all this about women's lib then? June Mussett and Jean Humby, pictured on duty in the university's student cloakroom, don't seem to have heard of it. Still this picture is not quite the 1990s. They're probably captains of industry by now! A 1996 report by Dr Robert McHenry (Oxford Psychologists Press) suggests that young women are generally more aggressive, arrogant and dishonest than their traditional predecessors. McHenry says employers are going to have to change their stereotyped ideas about the sexes. (Lovett Whitelam / *Wessex News*)

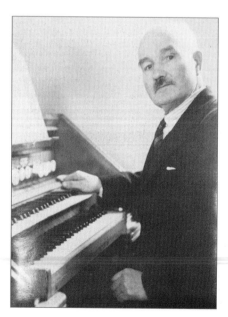

People used not to shout so loud about bettering themselves. My great-great-uncle Thomas Walker, pictured here playing Cadnam Church organ in the 1950s, went to Southampton to improve his chances and was very thankful for his good fortune. (G. Eacher)

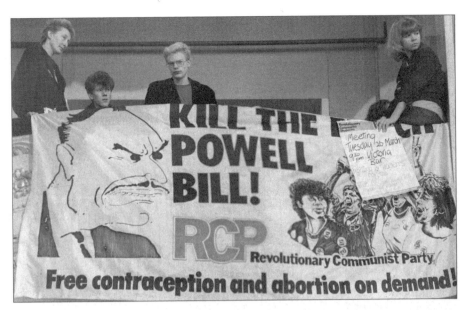

Feminist militancy thrived on university campuses like Southampton in the 1970s. Revolutionary communists put the view that women's bodies were their own, and that they should not be forced to go through with unwanted pregnancies or face back-street abortionists. Enoch Powell, an MP so controversial that even the Tories abandoned him over an immigration speech, thought otherwise, as this picture of local students shows. Dr Elaine Cooper, Director of Family Planning for Southampton Community Health Trust, said: 'Studies have shown that the average youngster has had ten months of sexual experience before they visit us . . . the clinics [which the Trust has been criticized for organizing] do not encourage them to have sex, they're already doing it.' (Andy Carter/*Wessex News*)

One of the entries in the world's shortest novel competion read: 'God laughed nastily.' I would have elaborated: 'Never more so than when he invented sex.' There are all sorts of horrors in the world, but nothing worries good people like sex. Genetic diversity is the objective but the social fallout is awful. The problem is that sex comes naturally but society doesn't. This is a sex shop in St Mary's Street photographed on 23 October 1982. Women campaigners argue, 'Pornography is the theory, rape is the practice.' That may be debatable but, like prostitution, pornography is a growth industry, thriving in spite of bans. Police are vigilant and recently closed down a vice den at 6 Buller Street, Newtown, where a search revealed whips and handcuffs. The trouble is in the hormones, of course. In 1957 Bardot made a sex and striptease film called 'A Woman like Satan', and a near-nude lifesize model of her was used in cinemas to promote it. Afterwards it was auctioned and Southampton seamen from *Queen Elizabeth*'s engine rooms were among the bidders. But a woman eventually bought it for her son's 21st birthday! (Andy Carter/*Wessex News*)

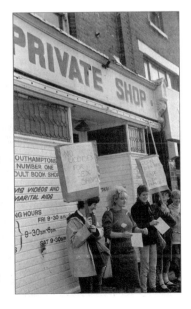

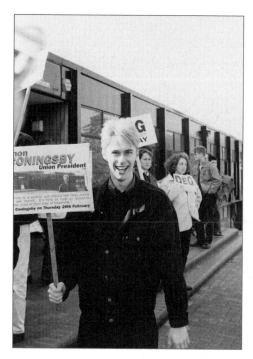

The government boosts university places and cuts budgets. Southampton Vice-Chancellor Howard Newby stressed the need for cooperation to fight the cuts and criticized the local paper for sounding alarmist. So there has been plenty for student politicians like Simon Coningsby, elected Student Union President for 1996/97 with 700 votes to campaign about. But student radicalism isn't what it was. (*Wessex News*)

The University of Southampton will not be among the hardest hit because it expanded less than most from the late 1980s onwards. But cuts of £5 million are expected and job losses are inevitable. The Vice-Chancellor says the university is planning for a future to benefit the city and I'm sure this man, described by the student newspaper as a 'visitor from Vulcan', would agree with him (*Wessex News*, 29 April 1996). It is of course Tory MP and Welsh Secretary John Redwood, who visited Southampton Conservative Association to talk about Europe. (Quentin Curran/*Wessex News*)

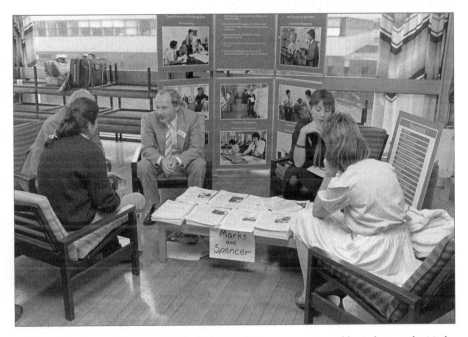

Shades of the halcyon hippy days back in the 1980s. The city is still spreading outwards as more people flock to the south coast's largest municipal borough and children leave home. Roads and houses thus devour open space and the habitat of voteless creatures. This is Bramble Lane where the student group has about as much chance of victory as Colonel Custer at Little Big Horn! (*Southern Daily Echo*)

Why protest when you have a career to think about? Here are some sensible students at the Marks & Spencer careers stand in the 1980s. It is a cruel world outside. Science graduates have the best chance of a job but 45 per cent of jobs are completely unrelated to degrees. John Exworthy, Director of Southampton University Careers Advisory Service, assured students in 1994 that firms target Southampton University students mainly because every faculty is strong and Southampton graduates are appreciated for their personal qualities – a good degree is never enough to get a job. (*Wessex News*)

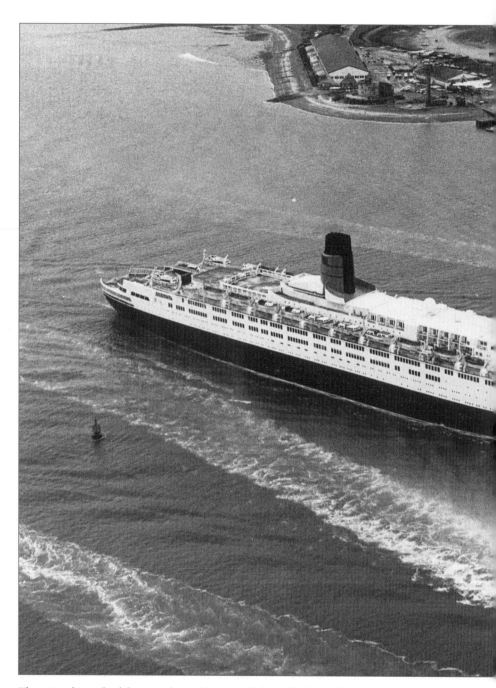

There is a hint of celebration about this view of Cunard's *Queen Elizabeth II* entering Southampton Water during the summer of 1969. The plucky little tugs look like proud circus ponies with plumes of sea spray jetting out behind them like manes. The giant liner in tow causes barely a rippple, which is more than can be said for the day she was launched. She was Clyde-built, but the Scots were affronted by her name because they had never recognized the first Queen Elizabeth. In the background on Calshot Spit is the old

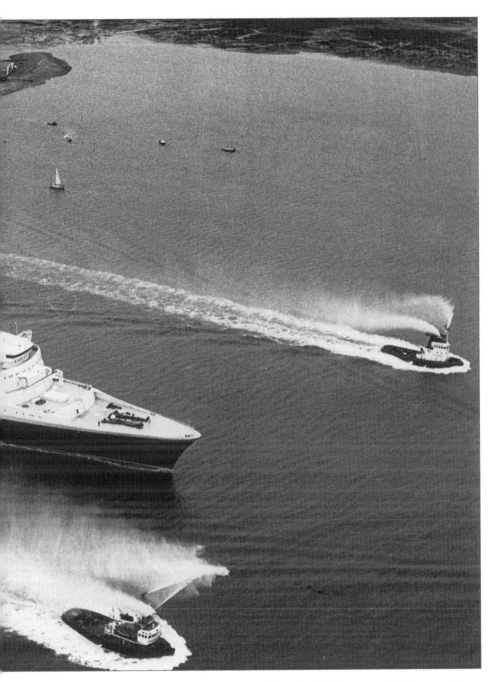

Calshot Castle, built by Henry VIII as part of his coastal defence system. It also served as an observation tower during the Schneider Trophy trials (*see* page 77). The big hangars and the old flying boat moored alongside, stand as reminders of those days of glamour and glory. The *QE2* was symbolic of the nation's hopes that the glory days were not gone forever. (*Southern Daily Echo*). The *QE2* was retired. She set off from Southampton on her final voyage on 11 November 2008, amid a fireworks display.

Assistant Chief Officer Alan House of Hampshire Fire & Rescue, photographed in the brigade archive, holding a copy of his book, *Gateway Fireman*, a history of Southampton's wartime fire service. Alan said: 'I grew up near the part-time fire station at Brockenhurst, and whenever the siren went I'd trot out to see them go. I was going to join the brigade as a cadet but my old-fashioned schoolmaster told me to learn a trade, so I became a panel-beater and joined Brockenhurst part-time. I also served sometimes at Lyndhurst. I got plenty of experience, and enjoyed it so much that I decided to join Southampton full-time. Most of us are happiest when we're doing the job we're trained for. We don't want fires to happen, but when they do we want to be there. We actually suffer more from morale problems in quiet periods. When I joined, training was localized, but now we provide training for up to thirteen brigades. Within ten minutes on my first shift I was on an engine going to a fire in the docks. It was very exciting, but I was anxious not to make a fool of myself and, as it was only a small incident, I just stood by the engine. There's great satisfaction in saving life. The first person I saved from a building was trapped in a blazing flat at Portswood on Christmas morning, 1971. I felt very good about that. When children are involved, it tends to hit home a bit harder. Some might say that firefighters have a warped sense of humour because sometimes we come across as rather callous. But that just gives us the balance to do the job. During my early days there were still a lot of old hands who had joined just after the war, and they helped us learn. Big changes came with local government reorganization in 1974, reducing the number of brigades by 30 per cent and setting stricter training rules. My role now is to ensure that all firefighters have the right equipment but I can still be called out to major incidents. Statistically, fires are on the increase and modern construction techniques generally produce more intense fires. Our three stations attend, on average, four thousand incidents a year. My job is my hobby. I've never felt that I didn't want to go to work. I found myself drawn to the brigade's history through being a small part of it myself.' (Alan House)

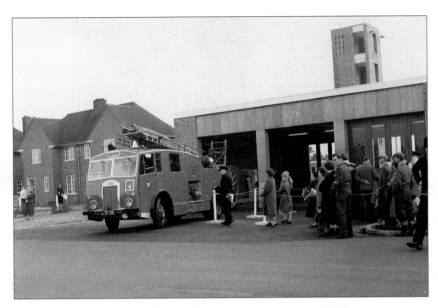

Opening Redbridge fire station, 25 October 1960. Alderman T. Dicks performed the ceremony, which was slightly disrupted when schoolboys got to the alarm buzzer before him and gave the impression there was a real fire! The new station was necessary as the borough expanded westward. The station included a 50 ft high training tower to cope with fires in modern high-rise flats. (Southern Newspapers)

The fire boat undergoing sea trials just before entering service on 11 April 1963. It was built by J.I. Thornycroft at Woolston and was originally moored alongside Town Quay. The crew came from a land station but had special training for the boat. It was an excellent floating pump, and was useful for fighting waterfront as well as ship fires. The boat was taken out of service in October 1986, and if a floating platform is needed now the fire brigade calls on one of the harbour authority's tugs. (Alan House)

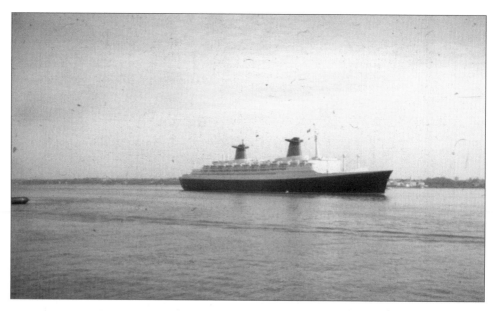

The 76,000-ton SS *France* passing Fawley oil jetty in 1962. This ship, a regular visitor to Southampton, was the world's longest liner. Sold to a Norwegian cruise line in 1979, the ship was renamed SS *Norway*. The good news is that SS *Norway* came back for a £3–5 million refit at the local A&P yard. The month-long refit secured 500 jobs and brought the ship up to the tough 1997 safety standards. Special care was taken to restore *Norway*'s elegant art deco interiors. (K. Eacher)

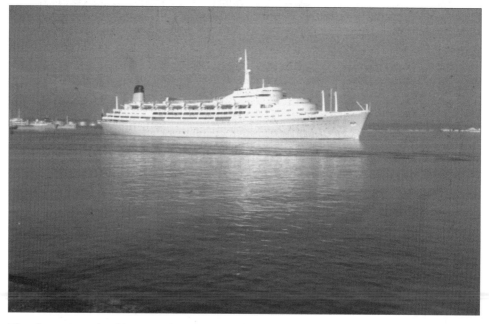

The glamour parade of liners passing Fawley was fairly continuous through the 1960s. This white giant's reflection shimmers on the water, adding drama to the scene. (K. Eacher)

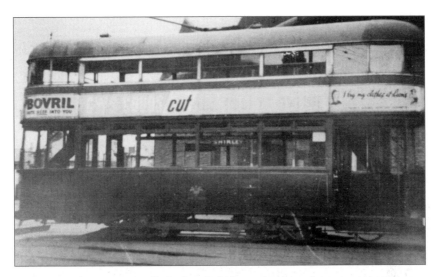

Shirley tram depot, 1948. A 'fan' of tracks led into the depot from a residential street. Southampton Corporation bought the private Electricity and Tramways Company in 1896 and in the horse-tram days there was stabling for a hundred horses at the main depot in Portswood.

The Mayflower as I remember it in the Gaumont days, early 1980s. This picture shows some interesting titles on screen as well as a stage show. Cinemas have moved on and the Mayflower concentrates on stage shows. It has been criticized for the high cost to local amateur group productions. 'Carmen' at the Mayflower in 1992 cost £14,000 and in 1996 the Musical Society faced £28,000 costs for a similar production. But costs are everything nowadays. We are light years away from when the Classic Cinema opened in Above Bar in 1936, showing newsreels; later it became the Classic Repertory Cinema showing established films. It suffered in the blitz, but went on to pioneer 3D films and the rather risqué continental films 'Sex in Sweden' and 'Intimate Teenage Secrets'. But not even those delights could save it from closure in January 1978. (*Wessex News*)

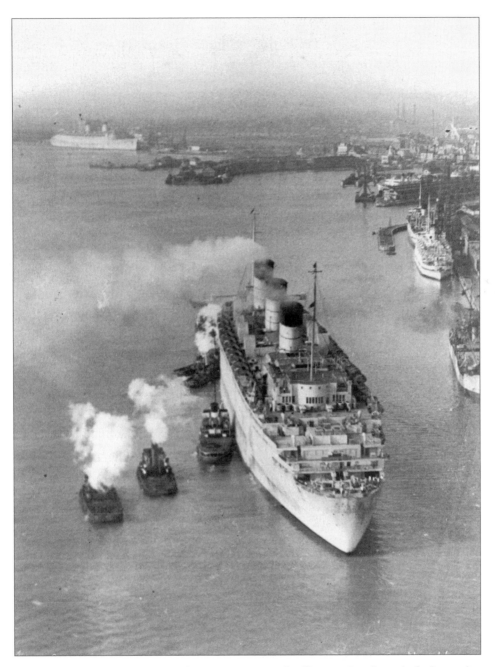

The *Queen Mary* in Southampton Docks, *c.* 1945. Tugs nestle affectionately at her side, looking rather like cygnets with a mother swan. The French-built *Queen Mary 2* went on to replace *QE2* as Cunard's flagship. The great lady has returned to a city in ruins, but still looking hopefully towards the future. However, sadly, many feel that Britain's shipyard bosses have killed their industry over the decades. (Cunard Archive/University of Liverpool)

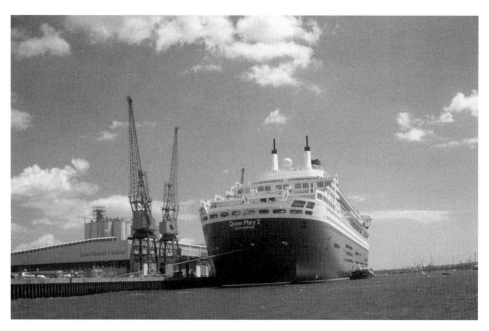

On 12 January 2004 the *Queen Mary 2* set sail on her maiden voyage from Southampton, England to Fort Lauderdale, Florida in the United States, carrying 2,620. With no serious home shipyards left, the *QM2* was the first Cunarder built abroad in France. (Raphael Sofair)

ACKNOWLEDGEMENTS

I have learned a lot from compiling this brief study. Meeting so many interesting and helpful people has given me much pleasure. Sadly there is not room to explain their individual contributions, though in some cases the text makes this obvious. I can only say here that all those listed below provided a mixture of words, pictures, guidance and advice which have shaped this book. I thank them all. Every reasonable effort has been made to trace photographic copyright holders.

B.A. Adams • Joyce Adams • Arcadia PR & Design • Mike Archbold
Associated British Ports • Elizabeth Baker • Band of Hampshire Constabulary
David Basson • British Power Boat Co. • J. Bromfield • S. Church • V. Church
N.G. Cook • N.J. Cook • F. Cubbage • R. Dickins • G. Eacher • Pat Flemming
Andrew George • B.K.B. Green • Hants Constabulary • Hants Fire & Rescue Service Alan House
Imperial War Museum • Dick Little • Nigel Impey •Martin Offer
Judy Ounsworth • Noel Pycroft • P. Rayner • R. Tyzack • Red Funnel Ferries
Southern Daily Echo/Southern Newspapers • Southampton City Record Office
Southampton University Students' Union • Colin Stacey
Cunard Archive/University of Liverpool • *Wessex News*.